ROMAN WARRIORS
THE PAINTINGS OF GRAHAM SUMNER

ROMAN WARRIORS

THE PAINTINGS OF
GRAHAM SUMNER

> 'On desperate seas long wont to roam
> Thy hyacinth hair, thy classic face.
> Thy Naiad airs have brought me home
> To the glory that was Greece,
> And the grandeur that was Rome.'
> EDGAR ALLAN POE

Text by **Simon Elliott**
Foreword by **Adrian Goldsworthy**

Greenhill Books

Roman Warriors: The Paintings of Graham Sumner

Greenhill Books

First published in 2022
by Greenhill Books, Lionel Leventhal Ltd
c/o Pen & Sword Books Ltd,
47 Church Street, Barnsley, S. Yorkshire, S70 2AS
For more information on our books, please visit
www.greenhillbooks.com, email contact@greenhillbooks.com
or write to us at the above address.

Text © Graham Sumner and Simon Elliott
Foreword © Adrian Goldsworthy
Illustrations © Graham Sumner
All Osprey illustrations © Osprey Publishing

All rights reserved. No part of this publication may be reproduced, stored in or introduced into a retrieval system, or transmitted, in any form, or by any means (electronic, mechanical, photocopying, recording or otherwise) without the prior written permission of the publisher. Any person who does any unauthorised act in relation to this publication may be liable to criminal prosecution and civil claims for damages.

CIP data records for this title are available from the British Library
ISBN 978-1-78438-719-8
Typeset and designed by www.mousematdesign.com
Printed and bound in China by 1010 Printing International Ltd.

CONTENTS

Foreword by Adrian Goldsworthy — ix

Introduction — 1

Chapter 1
The Early Roman Republic — 8

Chapter 2
The Later Republic and its Civil Wars — 31

Chapter 3
The Early Empire: Augustus to Tiberius — 42

Chapter 4
Claudius to Hadrian — 60

Chapter 5
The High Point of Empire: The Antonine and Severan Dynasties — 114

Chapter 6
The Fall of Rome and the Dark Ages — 154

Epilogue — 196

Bibliography — 210

Acknowledgements — 213

Artist's Dedication

To my parents

who introduced me to a love of history,

cinema and illustration.

FOREWORD

Reconstructing the past, especially the ancient past, ultimately comes down to imagining what it was like. What were these people like as individuals, famous or not, as groups and societies, and how did they live, how did they act, what did they do and why? All scholars work with mental pictures of the people, places and things they study. If we are honest, we accept this simple fact, and if we are doing our job properly then we try to base these pictures on the evidence and modify them as more is discovered or new ways are suggested of interpreting the data we possess; that's far more productive than setting out with a clear template already in your mind and hammering the facts into place to make them fit. It is then a question of trying to put all these mental pictures into words so that anyone listening to a lecture or reading an article or book shapes their own Roman world in their imagination. For an archaeologist or historian, you also do your best to let the audience know how much of all this is guesswork, and of just how many gaps there are in our evidence and understanding. Sometimes there is very little to go on.

Pictures are proverbially worth a thousand words, and this is why Graham Sumner's ongoing portrayal of the Roman army – and other things – is so very precious. Rather than struggling to describe something, it is so much easier and more effective to show a picture. With Graham's work you know that the reconstruction is impeccably researched, that there is a good chance that some of the work he has done in each case has been pioneering, that he has then thought long and hard about all the evidence, old and new, and only then produces the picture. In the process of planning and painting a picture, he has gone through all the stages of research and analysis, before committing himself to the final image. Inevitably there will be guesswork, whether it is a question of how that ancient sculpture should be understood, which excavated items of equipment might be worn together by the same man, and, most of all, what colour was his clothing or the device on his shield. With Graham's work you can be sure that he has spent a long time thinking through all the decisions about each and every detail.

This diligence is the mark of a first-class illustrator and relies not simply on extensive knowledge of the subject, but a sense of history. It lifts the pictures from mere decoration into really valuable contributions to understanding the ancient world. It requires someone able to do their own research and do it well, and that matters not just because it makes the final product more accurate, but because by the very nature of what he is attempting, an illustrator like Graham will ask fresh questions of the evidence. I well remember a talk he gave at the Roman Army School in Durham, looking not just at fabric components of Roman military uniforms, but at the possibility that symbols were used to designate ranks and perhaps other distinctions. This was taking existing evidence and using it in a wholly new way, making a very good case that there may well have been a system, even if we cannot decipher it at present. Like all truly good ideas, it makes great sense and even seems obvious – once someone else has pointed it out to you. (I notice that the Roman Army School gathering gets mentioned elsewhere in the book, and deservedly so, since its mix of interests, backgrounds and approaches to the subject is unmatched anywhere else, making it always a very thought-provoking meeting.)

Graham has spent a lot of time and effort researching fabrics and clothing in a military as well as a wider context. While I have not counted, I suspect that he has painted more images of Roman soldiers not wearing helmets or armour than just about anyone else. That in itself is a useful reminder that Roman soldiers did not spend twenty-five years permanently dressed in full battle order, and that many of their duties did not require all this hardware. Such a point may sound obvious, but it comes back to the mental pictures that we all carry around, and a common enough assumption is that a legionary equals a man in helmet, cuirass and carrying a shield.

Graham's work has a strong sense of the practical, drawing no doubt on his experiences of re-enactment with the Ermine Street Guard, who were pioneers in showing in a physical way what the illustrators were trying to depict.

Full-scale reconstruction and re-enactment involves the same process of research and deduction, and again often prompts new questions. As importantly, it reminds us not to view surviving artefacts simply as objects, to be categorised by style and date, but to remember that they served a purpose. That is true of helmets and armour, and also of buckles and brooches and everything else. Patterns of distribution of a brooch type can be very revealing, but we are missing something if we do not wonder just how it was used to fasten a cloak, whether it did the job well, was more for display than utility, and whether the owner possessed it because it was all he could afford or it was all that was available, or in preference to other types. The key is to remember that these items were worn or used for a reason and that most of them were everyday things – back then they weren't the 'Ely helmet' or the 'Corbridge lorica segmentata', etc. One of the hallmarks of Graham's paintings is that they show human beings, from another time and place and wearing uniforms and equipment of an era, but still people we can imagine living and talking. They don't show shop window dummies who are there simply to display the various items based on actual finds or imagery from the ancient world.

Graham follows a line of illustrators whose work has made a major contribution to how we understand the Roman army. Peter Connolly's *The Roman Army* (1975) more than anything else sparked my own interest in the subject. Asterix books, watching epic movies on TV – and the BBC's *The Eagle of the Ninth* – and being able to visit sites like Caerleon all helped, but really it was the detail of Connolly's pictures and the text supporting them that fired my imagination and grew into a fascination that has lasted to this day. He tried to show everything as clearly as possible, without the convenient plumes of smoke you often got in earlier reconstruction pictures of ancient sites, which usually concealed things we did not know. Ronald Embleton's pictures of the army on Hadrian's Wall were earlier, although I came to them later, and had something of the same detail and power. Like Graham's, their work brought the soldiers, their bases and their battles to life, and because all of them worked with the evidence, their interpretations changed as the evidence expanded and our understanding of it altered. The style of each is distinctive and instantly recognisable and I suspect has done a huge amount to form the mental pictures of the era all of us carry around in our heads. On the walls of my office, I have several Connolly posters from the scenes in his Legionary and Cavalryman books, others by Sumner of the auxiliary cavalryman from the Lancaster tombstone (p. 91) and of Pullo and Vorenus (see p. 41, with the not coincidental resemblance to the actors playing them in HBO's *Rome*). There are also some postcards by Embleton because I don't have any posters of his work.

You recognise a Sumner painting at first glance. His soldiers have a weathered look about them, and you sense that they are cold and wet, or too hot depending on the setting, and that they are tired, sometimes cheerful and sometimes pretty browned off. They look natural, whether laden down with heavy equipment, going about their tasks on or off duty, marching, patrolling or occasionally fighting. One of my favourites is the cavalryman in 'Sunset in the lands of the Deceangli', staring out at the view, his shield covered, and his blanket roll and a bag behind his saddle (p. 83). It's just the sort of image I try to conjure in my mind's eye and then describe when I am writing a novel, and at the same time a reminder of the practical aspects of campaigning when I am writing non-fiction – a soldier who cannot look after himself and his horse in the field is not much use to anyone.

As I say, Peter Connolly's artwork inspired me as a child and still does. I know of numerous archaeologists and historians of my generation who can say the same thing. In the years to come, I will lay good money that there will be a fair few academics one day who will say, 'Well, there were these paintings of a fort or of soldiers by Graham Sumner, and something went click in my head and … well, here I am.'

ADRIAN GOLDSWORTHY

INTRODUCTION

'Blame it on the illustrator.'
DR JOHN WATSON.

THERE IS NO FINER WAY of bringing a historical narrative to life than through the use of the finest quality artwork. Beautifully drawn and coloured images convey a sense of time and place that even the best writing cannot compete with. Indeed, more often than not it is the front cover illustration that first draws one's attention to a new book. Then, when enjoying its contents, the pictures become the page-turner helping drive the reader's interest.

As an enthusiast about all things Roman I have always been attracted to books featuring sumptuous colour plates. Indeed, that is how I first got to know the work of Graham Sumner, one of the leading historical illustrators of the age, with a portfolio without peer. Through serendipity, I now find myself frequently working with Graham when writing my own books on the Classical world, and count him as a firm friend. That is why it is an honour to have been asked to provide the text that accompanies this collection of his life's work on the Roman world.

Graham was born in Birkenhead, Merseyside in 1958. His two passions while growing up were history and art. He has very fond memories as a young boy of watching historical dramas on television, being enthralled by programmes like *The Adventures of Robin Hood*, *Sir Francis Drake*, *The Adventures of Lancelot*, *Richard the Lionheart*, *The Buccaneer*, and countless Westerns. And yet, as he got older, the focus of his interest became the world of Ancient Rome, which even today he freely admits became an obsession. He dates this to the first time he went to the cinema.

This was, of course, in the days of black and white televisions, with only very small screens. Graham says it is difficult to understand now the impact of seeing something on a huge cinema screen. The first movie he remembers seeing was the 1964 Samuel Bronston production *The Fall of the Roman Empire*, while he was on a family holiday to London. Graham says he distinctly recalls the movie being very dark and heavy with melancholy, plus there were lots of scenes set in snow. These features made such an impression on him that they still often appear in his work today, with the fabulous sets and costumes another source of later inspiration. Indeed, Graham says the movie is still his all-time favourite.

Graham naturally leaned towards an education in art at school, and went on to study fine art and illustration at the North East Wales Institute in Wrexham. While he was there Keith Bowen, one of

Graham has clearly always liked dressing up in costume and using props! Here, he poses as a Native American while at home in the 1960s. The contemporary TV influences are clear.

Introduction

Graham in character as a Roman auxiliary in the Ermine Street Guard at the Manchester Roman gateway reconstruction in the 1980s.

Graham's future partner Elaine as a Roman lady in a dining room setting. This was drawn in 1987 for a proposed book on Hardknott fort which sadly was never published.

Wales's best-known artists, lectured him. Graham fondly remembers the day when Keith took over a gouache painting (a technique using a mix of natural or synthetic pigments, gum Arabic and water) he was working on. He says that in those few moments he learned more about various painting techniques than in the rest of his time studying there. The gouache technique that Keith used, with his fingers blending in the paint, is something Graham still uses today. Though he originally painted in watercolour, Graham says that once he began painting archaeological reconstructions it quickly became clear that gouache on board was by far the most practical technique to use. He says this is because gouache produces a more opaque finish than watercolour, and also because it is a more forgiving medium. To an extent, you can paint over errors or make changes, something you can't really do with watercolour. Graham says it is therefore ideal to work with on reconstructions when archaeologists change their minds!

Graham was inspired by his time at the Institute and looked to follow a career where he could really indulge his passion for history and art. He was therefore delighted to be recruited by the Greater Manchester Archaeological Unit. Then, later, as his career progressed, he joined the Manchester Planning Department, working there in the graphics studio. Then in 2000 he decided it was time to become a full-time artist in his own right. He has worked as a highly successful and well regarded freelance illustrator ever since.

Graham has many inspirations when it comes to fellow artists. He particularly loves the work of Sir Lawrence Alma-Tadema, Jean Léon Gérôme, Franz Roubaud, Jozef Brandt, Alphonse de Neuville and Édouard Detaille. However his earliest inspiration came from the paintings of John Kenney, who illustrated many of the famous Ladybird 'Adventures from History' books, and the archaeological illustrators Amédée Forestier and Alan Sorrell. Graham also loved the work of the team of artists who worked for *Look and Learn* magazine. Some of these, and others, would later produce illustrations for the popular military publications produced by Osprey, including Gerry and Ronald Embleton and Angus McBride. It was a great thrill in Graham's life that one day he too would illustrate several books for Osprey.

Later Graham would meet the illustrator Peter Connolly whose book *The Roman Army*, published in 1974, would revolutionise many people's perceptions

Introduction

Graham's passion for drawing figures from history is not restricted to the Romans. Here is Bush Barrow man, based on archaeological finds now on display in Devizes Museum.

One thing that has always struck me personally about Graham's work is how amazingly lifelike his subjects appear to be, and here he has let me into his secret. Graham says that, inspired by fellow artists past and modern, he always uses costumes and props to provide inspiration and structure when creating his fantastic drawings. Indeed, he has a vast collection of these, with his friends many a time volunteering to dress for him in appropriate gear so that he can draw from life (and of course take photographs for use later on). Further, before painting an archaeological reconstruction, Graham often makes scale models from archaeological plans to help with lighting and perspective. To enhance this process Graham frequently draws on his collection of 12-inch action figures to work out a composition.

When I was fortunate to spend time with Graham I asked him what his favourite personal creations were and, given his huge portfolio, his answers were very interesting. He told me that his own favourite painting was the reconstruction of Castleshaw Roman fortlet near Oldham, perhaps a surprising choice until one considers the level of research needed to do the subject justice.

on the appearance of the Roman soldier. Graham met Connolly several times while a member of the world's first Roman re-enactment society, the Ermine Street Guard. In a reversal of roles, Connolly asked Graham to pose for an illustration in his forthcoming book on the Roman legionary. Graham served in the Guard for almost twenty years and owes the society and its enigmatic leader Chris Haines a great debt.

Inspired by such illustrious company, his career has spanned five decades. Indeed, Graham remembers a time before electronic publishing when one had to send a client the original artwork for this then to be passed to the printer. The illustration board usually used was built up like a multi-layer sandwich and the process could involve the printer peeling off the top layer with the painting on and attaching it to a drum scanner. The real downside of that method was that you were very lucky if you got the artwork back, and then only if it had survived the process. Graham says that that is the main reason he struggles to find originals of his work dating to before about 2005.

Graham loves this cover he painted for the book *100 Things You Should Know About Roman Britain* by Philip Steele.

Introduction

How it all begins. Graham has posed these figures as he wishes them to appear in his completed artwork. In this way they serve as the basis for the design he then brings to life using his gouache painting technique.

The completed scene based on the photo (left), with a Byzantine emperor being dressed, in a plate from the Timothy Dawson book *By the Emperor's Hand*.

Graham also loves his Hollywood Romans series of full-length portraits, where he draws famous Roman figures and warriors as they have been portrayed on screen over the years. He says it was especially relaxing painting those since there were no experts to consult to ensure that the details were correct! Moreover, Graham says it has also been great fun meeting some of the actors who are portrayed in his paintings at Comic Con conventions. More broadly, though, Graham says that he is proud of any of his work featuring Roman military clothing, mainly because no academic has really covered the subject to the same level of detail as he has.

While famous for his printed work, Graham's fabulous artwork hasn't just been used to illustrate wonderful books covering all aspects of the Roman world (these are detailed in the bibliography), but also in exhibitions around the world. The list of these reads like a roll call of all of the great Roman military campaigns. Locations of these fine displays include the Grosvenor Museum in Chester, the Archaeological Museum in Durham, Ribchester Roman Museum, Lancashire Museum, Santi Bianchire Re in Ravenna in Italy, the Museu d'Història in Tarragona in Spain, the PAM Velzeke in Belgium, the Amphitheatre Museum in Grand in France, the Musée Gallo Romain in Saint Romain-en-Gal in France, the Roman Villa Museum at Loupian in France, the Vindonissa Museum in Brugg in Switzerland, the Augsburg Roman Museum in Germany, the Regensburg Museum in Germany, the Kalkriese Museum in Germany, and the world famous Vindolanda Museum on Hadrian's Wall.

An extremely shy person by nature, Graham has actually been surprised to discover that he really enjoys giving public talks at the Durham Roman Army School, although admittedly often after many sleepless nights beforehand. His talks on Roman costume have been very well received, a high point being his lengthy hour and a half discussion of the Roman army on screen, which was a huge success. With all the laughter throughout, Graham says he began to understand the buzz comedians must get on stage. The chairman, highly respected archaeologist David Breeze, simply said 'Well, follow that.'

Graham's wonderful drawings have also been used on the interpretation panels at Moresby and Ravenglass Roman forts in Cumbria, Castleshaw Roman Fortlet in Greater Manchester, Denbigh in North Wales and at the wider Vindolanda site on Hadrian's Wall. It is in these iconic locations that Graham's work really brings to life the world of the Roman Empire for the thousands of members of the public who visit them each year. In this way, he is thus an inspiration for every future generation of Roman world enthusiasts.

DR SIMON ELLIOTT

Opposite: The famous fourth/fifth century AD Alexandrian Neoplatonist philosopher, scholar and teacher Hypatia. Graham is a regular contributor to *Ancient History* magazine and this is one of his recent illustrations.

Introduction

Introduction

Graham's own favourite illustration, Castleshaw fortlet in the Saddleworth parish of the Metropolitan Borough of Oldham in Greater Manchester, England. This was built to hold the line as the Roman military advanced northwards, growing the province of Britannia. Painted for the Greater Manchester Archaeological Unit which sadly no longer exists, for use on an interpretation panel situated at the site.

Introduction

CHAPTER 1
THE EARLY ROMAN REPUBLIC

'Every brush stroke is torn out of my body.'
PAUL ASHBY, *THE REBEL*, 1961.

THE VILLANOVAN/ETRUSCO-ROMAN TRANSITION

THE FIRST DETAIL WE HAVE of the Roman army comes from a time when the city was under Etruscan rule, before the Republic began with the overthrow of Tarquin the Proud in 509 BC. This early Etrusco-Roman army adopted the Greek-style hoplite phalanx as its main line-of-battle formation, after Etruscan interaction with the Greeks of Magna Graecia in southern Italy. The term phalanx meant a deep formation of armoured spearmen whose front ranks fought with their long spears in an overarm thrusting position. Each front-rank warrior was protected by an interlocking series of *aspis* – the large round body shields carried by the hoplite and his neighbours. Warriors in the rear ranks added their weight to the formation and replaced those who fell in battle. The Etrusco-Roman phalanx was supported on its flanks by Roman/Latin troops who still fought in a loose formation as had their Villanovan ancestors. Common weapons for these troops were spears, axes and javelins.

In this fine image, based on research by Dr Raffaele D'Amato, we see three warriors of the mid–late sixth century BC, as the Greek influence was becoming evident with the first appearance of the Etrusco-Roman hoplite. The figures at left and centre are still armed and equipped as their better-off Villanovan forebears, with a superior panoply of spear, bronze short sword, bronze-faced shield and archaic bronze pectoral. Their helmets are also typically Villanovan. However, the figure at right is a fully equipped Etrusco-Roman hoplite. Note his *aspis* shield, *doru* long-thrusting spear and bronze bell cuirass, the latter so-called because of the design across the stomach and lower chest area. This is a typical type of early hoplite bronze cuirass design, found widely across the eastern Mediterranean in contemporary imagery and in the archaeological record. The warrior also wears a very fine example of an Apulo-Corinthian helmet, a typically Italian development of the more common Corinthian-style hoplite helmet.

The Early Roman Republic

The Reforms of Servius Tullius

This Etrusco-Roman way of fighting, with a solid phalanx of hoplites in the centre and lighter troops on either side, was formalised by Servius Tullius, the first of the great reforming Roman military leaders and second Etrusco-Roman king (578–535 BC). He instituted the Servian Constitution in the mid-sixth century, which divided Roman society into seven different classes. Each had a different military commitment to the Roman state based on wealth. Top of the tree were the *equites*, these being the wealthiest citizens who could afford a horse and thus formed the cavalry. Next were the First Class, the Etrusco-Roman phalanx of earlier armies which was now formed of 80 centuries of hoplites, followed by the Second Class of 20 centuries of spearmen with helmet, greaves and the *scutum* rectangular or oval shield (this a generic term here rather than the later classic legionary shield). Going down the scale, next was the Third Class, comprised of 20 centuries of spearmen with helmet and *scutum*, then the Fourth Class of 20 centuries of spearmen with *scutum* only. Finally in terms of military commitment were the Fifth Class, 20 centuries of lightly equipped missile-weapon armed troops. At the bottom of society in this period were the *capite censi*, this translating as head count and meaning those in Etrusco-Roman society with little or no property. This class had no military commitment.

In this plate, also based on the research of Raffaele D'Amato, we see three leading warriors from the army of the period. At left and centre are two officers from the Second Class with their traditional Italian shields and short spears. Both are well equipped with armour, the warrior at left wearing a bronze pectoral with leather *pteruges* and a Apulo-Corinthian helmet. Meanwhile his counterpart in the centre wears a hauberk of bronze scales, can afford a leg greave and has a conical helmet of native Italian design similar to the later 'Negau' type. However, despite their fine equipment, both played only a supporting role in battle given the preeminence of the First Class hoplite as the battle-winning troop type in Roman armies of this period. Here these are represented by the figure at right, equipped with *aspis*, cuirass made from layers of linen glued together to form a stiff shirt up to 5cm in thickness, bronze greave and an expensive Chaldician-style helmet with prominent crest. He has cast aside his *doru* and holds one of the most common types of hoplite sword, the vicious-looking *kopis* often used in early Roman armies.

LATER FIRST CLASS TULLIAN HOPLITE

FIRST CLASS ROMAN WARRIOR EQUIPPED as a hoplite around the time of the Battle of Allia in 390 BC. He wears a panoply which dates to immediately before the period of the Camillan military reforms, and is equipped with the best military equipment of his day. Alongside his *aspis* shield, *doru* spear and *kopis* sword he sports a muscled bronze cuirass, these so expensive that later they were usually only worn by officers. He also has his Thracian/Phrygian style hoplite helmet ready to put on. This design, an evolution of the Attic helmet type which included design elements of the famous Thracian/Phrygian cap, featured a peak at the front which extended around both sides to give eye and ear protection. It also commonly featured extended bronze cheek pieces, these often designed to resemble a beard, and a crest across the scalp.

Roman soldiers equipped in this way were, however, comprehensively vanquished by the Senones Gauls of Brennus in the Allia campaign. The Roman defeat here was on such a shocking scale that shortly afterwards the Gauls were able to sack Rome, prompting the widespread military reforms of Marcus Furius Camillus.

The Early Roman Republic

Titus Manlius Imperiosus Torquatus

The Tullian military system was quickly abandoned after its dramatic failure at the Battle of Allia in 390 BC in favour of a brand new organisational structure for the armies of Rome and its Latin allies. This was called the Camillan system after its founder Marcus Furius Camillus, leading soldier and statesman of the age. This initially featured two legions, each commanded by a consul, with six *tribuni militum* subordinates serving beneath him. These new legions numbered 3,000 men each, though this quickly increased to 6,000, all organised into maniples (hence the name manipular legion).

Within the Camillan legion there were three classes of line-of-battle troops, their classification based on experience and age rather than wealth. The specific classes were the *triarii*, *principes* and *hastati*. The first were veterans wearing helmet and body armour and carrying the new *scutum* full-body shield. They were armed with the *hasta* thrusting spear and replaced, in part, the old Tullian First Class. Meanwhile the *principes* were older warriors, also wearing helmet and body armour and carrying the *scutum*. Initially armed with the *hasta*, they replaced these with *pila*, heavy throwing javelins of Spanish origin, as the Republic progressed. The *principes* also replaced, in part, the old Tullian First Class. Finally came the *hastati*, 'the flower of young men'. Again equipped with helmets, though with less body armour, they too carried the *scutum*, initially the *hasta* and later *pila*, together with swords. They replaced the old Tullian Second class. All three types were styled as 'legionaries' from this point, and fought in the *acies triplex* formation of three lines, with the *hastati* deployed at front and *triarii* at the rear.

The Camillan legion was completed with three lesser classes of warrior. These were called the *rorarii*, *accensi* and *leves* who replaced, sequentially, the old Tullian Third, Fourth and Fifth classes. They were support troops rather than line-of-battle troops and became less important as the Republic progressed.

The new Camillan legions were soon put to the test, and in 361 BC at the Battle of Arno River it was payback time for the Gauls. Here a Roman army under the *dictator* Titus Quinctius Pennus Capitolinus Crispinus defeated a band of Gauls closing on Rome. The turning point of the engagement proved to be the actions of a young military tribune called Titus Manlius Imperiosus who accepted the challenge of a Gallic champion much larger in size and defeated him in single combat. Having slain his opponent, he then took a golden torque off the his enemy's dead body, earning his *cognomen*, Torquatus.

The life and death duel between Manlius and his enormous Gallic opponent is pictured, with the former wearing the typical panoply of a Roman officer of the period. This includes a fine quality bronze muscled cuirass, *scutum* and long leaf-bladed iron sword. His helmet is of the Greek Attic type, a development of the Chaldician design lacking a nose guard.

Legionary veteran of the Pyrrhic War

THE SIMPLE SQUARE PECTORAL ARMOUR shown here is synonymous with the early Republic. However, the *scutum* shield design remained in use for centuries afterwards, while the Montefortino style of helmet was also one of the most popular and enduring items of Roman military equipment, seeing service in various versions right up until the early years of the empire. This image was painted for Ross Cowan's *For the Glory of Rome* published in 2007.

The Early Roman Republic

Roman Warriors

Polybian Legionaries, Second Punic War

THE MANIPULAR LEGION FURTHER EVOLVED into what historians call the Polybian system after Rome's conflict with Pyrrhus of Epirus and his Hellenistic army in the early third century BC. Polybius was the leading second-century BC Greek historian who described Rome's conflicts in the period.

The Polybian legions were again deployed in the *acies triplex* formation, this time featuring 1,200 *hastati* in 10 maniples of 120 at the fore. Next came 1,200 *principes* organised in the same way, and finally 600 *triarii* in 10 maniples of 60. Each of the maniples featured two centurions, two subordinates and two standard bearers. The major change was the disappearance of the *leves*. These were replaced by 1,200 *velites*, specialist skirmishers divided among the other maniples. The *rorarii* and *accensi* also disappeared at this time. In addition, the Polybian legion also featured a formal cavalry component, 300 strong and divided into 10 *turmae* of 30 troopers each.

These legions, used to such great effect in three Punic Wars, four Macedonian Wars and the Roman–Seleucid War, were highly efficient and adaptable, for example learning from their three great defeats in Italy in the Second Punic War ultimately to beat Hannibal at the Battle of Zama in 202 BC and thus win the conflict.

Pictured are three Roman legionaries of the period, again based on research by Raffaele D'Amato.

At left, a well-equipped officer of the *hastati* with bronze muscled cuirass beneath his cloak and wearing a typically Italian helmet with feather crest. At centre, a veteran *principes* with *lorica hamata* mail hauberk, an armour type adopted from the Gauls, and a well decorated Apulo-Corinthian helmet. He throws the heavier of his two *pila*, which is shown in detail here. These heavy throwing javelins were likely of Spanish origin (though some argue Etrsucan), and adopted by the Romans in the fourth century BC after the reforms of Camillus. Each legionary carried two, one heavy and one light, both with a barbed head and long iron shank, with a substantial lead weight sitting behind the shank in the socket where it joined the wooden shaft of the weapon. This combination gave the *pilum* tremendous penetrating power, with the shank designed to bend on impact so that even a simple hit on a shield would make the latter's use impossible. The lighter *pilum* was thrown at range and the heavier immediately prior to impact, before swords were drawn.

The figure at right is a senior officer, again wearing *lorica hamata* and a Chaldician helmet with a large crest, designed for visibility on the battlefield. Note that he wears his sword on the left-hand side; this was increasingly popular among legionary officers from this time (unlike his *hastati* counterpart shown at left).

Numidian Warrior

Given the limited diversity of troop types in the Camillan, Polybian and later Republican legions, additional troops types were recruited as mercenaries and allies to fulfill supporting roles on the battlefield. These all fought in their own native fashion.

In their wars against Carthage in the western Mediterranean the Romans first came up against troops from Gaul, Spain and North Africa, the last including Numidians as depicted here. Impressed, they recruited all such types in large numbers. The Gauls were renowned for their fierce charge, while the Spaniards provided the inspiration for the *pilum* and (as detailed later) *gladius hispaniensis*. Meanwhile, from North Africa Rome recruited Numidian light horse, famous for skirmishing and armed with javelins with which they showered their foes, and light foot. The warrior shown is one of these, equipped with a substantial short spear and targe-like hand shield. Note the dagger strapped to his inner left wrist. Most Numidian foot troops were skirmishers, though some were later trained to fight in Hellenistic and even imitation-legionary fashion.

The Early Roman Republic

The Early Roman Republic

Roman Velites and Seleucid Horse at the Battle of Magnesia

The Battle of Magnesia in December 190 BC, fought near Mount Sipylus in western Anatolia between the legate Lucius Cornelius Scipio and the Seleucid king Antiochus III, was one of the three key battles in the early second century BC where the armies of the Roman Republic broke the power of the Hellenistic kingdoms in the eastern Mediterranean. The other two were at Cynosophalae in 197 where the Romans defeated Philip V's Macedonian army, and Pydna in 168 where Philip's son Perseus was similarly humiliated.

Here at Magnesia we see an encounter at the beginning of the engagement when a screen of *velites* skirmishers deployed across the front of the Roman manipular battle line has been engaged by Seleucid mounted troops. Two such cavalrymen are depicted, that at left a Galatian medium trooper equipped with a typical Gallic shield featuring a central spine and carrying a short spear. That at right, the better equipped of the two, is a Tarantine-style skirmisher equipped with a shield bearing a typical star of Macedon and short spear. Such light cavalry were specifically used for skirmishing and scouting, and were a key component of Hellenistic armies. 'Tarantines', wherever they were recruited, were named after Taras in Magna Graecia (modern Taranto in south-eastern Italy) where the type originated.

Meanwhile, note the typical attire and panoply of the Polybian-legion *velite*, equipped with a handful of long-tanged javelins. Such skirmishers were usually better equipped than their foot counterparts in opposing armies, wearing helmets as standard issue, with these often covered in a wolf pelt.

Cavalry Clash, Battle of Magnesia

Clash between a Seleucid Agema guard cavalryman and a Roman mounted trooper, Battle of Magnesia. By the time of the Cynosophalae, Magnesia and Pydna campaigns, most Hellenistic heavy cavalry had transitioned from the 3.5m *kontos*-lance-armed shocktroopers of the armies of Alexander and his successors to a lighter cavalry type equipped with a short spear and large round shield featuring a prominent central spine. The vector of transmission of the new type of panoply seems to have been Pyrrhus' campaigns against the Romans in Italy where he was impressed with the shields used by his Roman cavalry opponents. The only types fighting in the traditional Macedonian heavy cavalry style by this time were the Seleucid king's guard cavalry, and here we see such an Agema trooper on the left with his lance carried overarm, also sporting a fine-quality bronze-faced shield (smaller than the standard Hellenistic type by this time) featuring a laurel-wreath decoration.

Meanwhile, his Roman opponent features the standard panoply of the Roman heavy cavalryman of the Polybian legions, with a mail hauberk of Gallic design and leather *pteruges* protecting the upper arms, thighs, groin and midriff. Given the small size of his shield, this may be an officer.

Phalanx Collapse

A PHALANX COULD EASILY BREAK formation over rough terrain. Gaps in the line could be exploited by the more flexible legions. Here a phalangite realises his fate as a phalanx collapses around him and Roman legionaries rush in to close quarters. Painted for the 'Roman Conquests' series produced by Pen and Sword.

SELEUCID CATAPHRACTS CHARGE LEGIONARIES, BATTLE OF MAGNESIA

For the most part Antiochus III's army at Magnesia struggled against the Romans, except on the king's right wing where his super-heavy cataphract cavalry charged down the *hastati* and *principes* opposite and broke the Roman left flank. Such mounted warriors emerged in the Hellenistic world in the armies of the Graeco-Bactrian kingdom following contact with the Parthians and were soon in service with the Seleucids. Troops equipped in this way, featuring fully armoured horse and rider fighting in deep formations, used the same 3.5m *kontos* as the Agema detailed above.

The legionaries depicted are classic later *hastati* or *principes* wearing *lorica hamata* mail hauberks, Montefortino-style bronze helmets (increasingly ubiquitous by this time) with feather plumes and carrying *scutum* shields. Even in close-order formation they proved no match for the thunderous charge of the Seleucid cataphracts in the battle. However, Antiochus failed to control the pursuit, leaving the rest of his army to its fate at the hands of the Romans. Soon the battle, and with that the war, was lost and the Romans had secured their first firm footing in Anatolia.

ROMAN WARRIORS

CHAPTER 2
THE LATER REPUBLIC AND ITS CIVIL WARS

'He's written a book, which is not a diary but a scientific study, to do with soldiering.'
GENERAL AIREY, *THE CHARGE OF THE LIGHT BRIGADE*, 1968.

SULLAN CENTURION AND MARIAN LEGIONARY

THE CLASH BETWEEN THE PRO-SENATE *optimates* and radical *populares* factions in Roman politics broke into open conflict in the late 90s and early 80s BC during the period of dominance of Sulla, champion of the former, and Marius, champion of the latter.

The first figure depicted here is a Sullan centurion, based on a famous relief found in the open-air Theatre of Marcellus in Rome. Wearing a fine plumed helmet, his panoply features an iron or iron-plated cuirass and greaves, and unusually an *aspis* hoplite-style shield featuring an image of Athena (or Minerva). The shield might either be stylised in the original sculpture to give it a classical theme, or depict an actual shield used by the real owner, this an affectation to set him apart from the rank-and-file legionaries. Note the silver and ivory decoration on the shoulder pieces, and the Medusa images above Winged Victory on the greaves.

Meanwhile, the second figure depicts a classic Marian legionary. The great seven-time consul and military leader completely reformed the Polybian manipular legions after the series of shocking defeats inflicted on the Romans by the Germanic Cimbri at the end of the second century BC. From 107 BC, the legions were now based on the century rather than maniple, with each of a legion's 6,000 warriors armed in exactly the same way, rather than differentially as with the earlier *hastati*, *principes* and *triarii*.

Such a legionary is depicted here, wearing a Montefortino-type helmet with red plume, classic *lorica hamata* mail armour (including high-quality decorated leather epaulettes) and carrying a large *scutum* body shield featuring unusual angular sides. For weaponry he carries one of his two *pila* lead-weighted javelins, though his principal weapon here is the *gladius hispaniensis* worn on his right hip, its baldric attached tightly to the legionary's metal-plated belt. Finally for weaponry, he also wears a *pugio* dagger with fine swan-necked hilt on his left hip. Ready for campaigning late in the year, he also wears leather *bracae* breeches and leg bindings above his *caligae* boots.

Julius Caesar in the Front Line

GAIUS JULIUS CAESAR WAS THE leading warlord of the later Roman Republic, his rivals for the title including the likes of Sulla, Marius, Cinna, and his contemporaries Crassus and Pompey. All of the various military and political leaders of the age displayed a combination of traits including personal bravery, the ability to be brutal when necessary, strategic and tactical prowess, the ability to communicate with audiences high and low and great and small, grit – that most Roman of traits – which meant they kept coming back, the charisma to inspire on a large scale, and decisiveness. Caesar was the only one who had them all, and because of this was the most constantly and conspicuously successful of them.

Here we see him showing great personal bravery and leadership at the Battle of the River Sambre (then known as the Sabis) in 57 BC, helping stabilise the faltering XIIth legion, and then leading his army to ultimate victory over the Belgic Nervii. Caesar is depicted wearing a simple iron or iron-plated cuirass, this based on a near contemporary early Augustan period monument from Narbonne. He holds a *gladius hispaniensis* poised to strike above his shield rim, the latter a standard legionary *scutum* seized from a fallen trooper.

ROMAN WARRIORS

CAESAR'S LEGIONS

JULIUS CAESAR WAS A VERY shrewd operator, who knew that he could only achieve his personal ambitions if backed by loyal legions. To that end, he was particularly adept at accruing new legions to ensure weight of numbers told in his favour. For example, when given the governorship in Gaul in 59 BC he inherited four legions, VII, VIII, IX and X. He knew these were insufficient for the far-reaching conquests he planned in what became known as his Gallic Wars, and so immediately set about recruiting new legions. His first new foundings were legions XI and XII in 58 BC at the point his campaign began, then later *legio* XIII and *legio* XIV in 57 BC, *legio* XIV again in 53/52 BC after it had been destroyed, *legio* XV also in 53/52 BC, and finally the native Gallic *legio* V *Alaudae* and also *legio* VI in 52 BC.

Here, the figure on the left is a battle-hardened trooper of *legio* V *Alaudae*, his Montefortino-Buggenum style helmet featuring a crest that imitates the crested lark, thought by some to be the inspiration for the legion's name. He wears standard *lorica hamata* mail and carries a *scutum* wrapped in a leather all-weather covering, while his *gladius hispaniensis* is sheathed on his right hip. He carries a *pilum* in his right hand.

The figure on the right depicts an *aquilifer* standard bearer of *legio* X *Equestris* at the time of Caesar's first 55 BC incursion to Britain. Effectively Caesar's own legion, this was the elite military formation of the age. He had personally founded it in 61 BC when governor of Hispania Ulterior. It later received the *cognomen* Equestris after Caesar famously mounted some of its legionaries in a bid to fool the German King Ariovistus during a parley in the 58 BC campaign against the Suebi.

The *aquilifer* was the senior standard bearer in the legion, carrying the silvered-bronze eagle standard that only left the legionary fortress or camp when the entire legion was on the move. An *aquilifer* of the Xth legion famously shamed his fellow legionaries in 55 BC when they proved reluctant to disembark during Caesar's first invasion of Britain, by leaping into the shallows off the east Kent coast and declaring (according to Caesar's, *The Conquest of Gaul*):

> Leap, fellow soldiers, unless you wish to betray your eagle to the enemy. I, for my part, will perform my duty to the Republic and to my general.

The shamed legionaries then swarmed ashore to protect their eagle, with victory against the native Britons defending the coastline quickly following.

Our figure here wears a classic *aquilifer* panoply of the time, featuring a bronze Coolus-type helmet covered with a bearskin head-dress, *lorica hamata* hauberk, a round target-style shield, and with his *gladius* carried on the right hip and *pugio* on the left. This standard bearer has clearly prepared for the poor weather for which Britain was famed in the Roman world by wearing *bracae* breeches and socks. The figure, including the *aquila*, is based on an example shown on a coin of Gaius Valerius Flaccus, an early first-century BC consul.

GALLIC CENTURION WAR

THIS FIGURE IS A CENTURION OF the same period as the preceding pair, his legion indeterminate. He wears an altogether finer panoply, with iron or iron-plated Gallic Agen-Port type helmet featuring an unusually broad rim, *lorica hamata*, classic late Republican oval *scutum* and iron or iron-plated greaves. His *gladius hispaniensis* has been drawn from its scabbard carried on the left hip where it was usually worn by centurions to distinguish them from rank and file legionaries, while his *pugio* dagger is sheathed on his right hip. Graham has sourced much of the detail for this fine figure from late first-century BC sculptures found in Aquileia in north-eastern Italy.

The Later Republic and its civil wars

A Germanic Cavalryman and a Gallic Mounted Warrior, Alesia

Later Republican Roman armies, particular on campaign abroad, lacked an indigenous cavalry component and so relied on allied and mercenary troops to fulfill this vital battlefield function. While the legions were often preeminent on the battlefield, this counted for naught if the Roman commander was unable to scout ahead, protect his flanks and rear on the move and in battle, and pursue a broken enemy. These were all roles best performed by cavalry.

By the time Caesar mounted his bloody campaigns in Gaul in the 50s BC most of his mounted troops were allied Germanic and Gallic horsemen recruited in north-western Europe. They were noted for their fierce charge, with many infamous as headhunters, a trait which they carried into the Principate phase of empire when they then formed the bulk of the regular auxiliary cavalry in the west.

In this plate we see a typical encounter between a cavalryman of Germanic origin fighting a Gallic counterpart as Caesar's victory over the Great Gallic Revolt was completed at the Siege of Alesia in 52 BC. The Gaul, possibly an aristocrat, carries a decorated Gallic shield with central spine, shortened *lorica hamata* mail hauberk more suitable for use in the saddle, fine Gallic helmet and short cavalry spear. The Germanic warrior, a Roman allied trooper, is an unarmoured, irregular.

Centurions Fighting in Caesar's Civil Wars

Here Graham depicts a great rarity from the Classical world historical narrative, namely two ancient warriors who are actually named in contemporary writing. These are the famous centurions Titus Pullo and Lucius Vorenus, mentioned in the campaign dispatches of Julius Caesar. Though some believe they were members of the XIth or XIIIth legions, Caesar never in fact says which units they belonged to. Indeed, all we learn from Caesar is that one of their legions at the time was commanded by Quintus Cicero, a Roman legate and statesman who was the younger brother of the famous Marcus Tullius Cicero.

Pullo, at left in this composite image, is shown in his undress uniform. This portrayal is based on the early Augustan period tombstone of Minucius Lorarius in Padua. Meanwhile Vorenus wears equipment based on the same source material as his counterpart on page 37, namely the late first-century BC sculptures in Aquileia. This includes an iron or iron-plated Gallic Agen-Port type helmet, *lorica hamata* mail covered with a decorative girdle featuring a central figure of Victory, high quality *phalerae*, and an officer's well-produced *scutum*. The quality of the shield shows him to be a centurion of senior rank. Vorenus holds a classic *gladius hispaniensis* in his right hand.

The Later Republic and its Civil Wars

CHAPTER 3
THE EARLY EMPIRE: AUGUSTUS TO TIBERIUS

> 'Nobody bought Rembrandt, Lautrec, Van Gogh.
> It is a mark of true greatness when nobody buys.'
> ARTIST IN CAFÉ, *THE REBEL*, 1960.

EARLY AUGUSTAN CENTURION

GAIUS OCTAVIUS (BETTER KNOWN AS Octavian) was the last man standing in the final round of vicious Roman civil wars in the later first century BC. He was first recognised as *Augustus* by the Senate in 27 BC, this the event that traditionally brings the Roman Republic to an end and ushers in the Principate phase of the Roman Empire. This lasted through to the end of the 'Crisis of the Third Century' when Diocletian became emperor in 284, its name derived from the term *princeps*, meaning chief or master, with the emperor therefore officially regarded as the principal citizen of the Empire. Though *princeps* was not a formal title, it was a style subsequently assumed by each emperor on his accession. In reality it was a conceit, allowing the empire to be explained away as a simple continuance of the Republic when in reality it was a true dictatorship. With the accession of Diocletian, we then talk of the Dominate phase of empire.

However, it is the early Principate Roman soldier who is most recognisable to a modern student, with the centurion shown here dating to the period when the Republic transitioned to empire. The warrior shown is a slight variation on the Aquileia and Padua source material already referenced, while his shield motif is based on the same Narbonne sculptures mentioned as a reference for Caesar's armour. The shield colours, as in all examples in this volume, are mainly hypothetical but based on colours frequently used in Roman art.

The Early Empire: Augustus to Tiberius

ROMAN WARRIORS

The Early Empire: Augustus to Tiberius

Centurions of the Varian Disaster, AD 9

After years of civil war savagery, Augustus' initial aim as the new *princeps* was to provide stability across the now vast territories incorporated into the Roman world. This included consolidating the huge military establishment he had inherited as the victor of the final round of civil wars, especially by reducing the number of legions from around sixty to thirty. However, even though the new *Pax Romana* brought peace within the embryonic empire's borders, Augustus' foreign policy remained expansionist. As a priority he completed the pacification of northern Spain, bringing the Cantabrian Wars there to an end. His legions and newly formed auxiliaries then campaigned in North Africa, the East and along the Danube, where he soon established new imperial frontiers.

However, his most high-profile campaign was the attempt to expand Rome's northern footprint beyond Caesar's Rhine frontier into 'Germania', the name given by the Romans to the densely forested vastness there. Augustus alighted on the idea of occupying the lands between the Rhine and Elbe as the first century BC came to an end. His initial aim was to create a buffer zone to prevent the increasingly frequent raids by the German tribes based outside imperial territory.

The first series of Roman campaigns against the Germans were highly successful, initially under Nero Claudius Drusus and later his brother (and future emperor) Tiberius. The next natural step was to 'Romanise' the lands there, prior to any attempt to create new long-term provinces in the region. The man Augustus chose for the job in AD 7 was Quintilius Varus, the husband of his great-niece and a highly experienced though strict administrator. Varus had earlier been the governor of Africa and of Syria, earning a reputation as a successful diplomat and bureaucrat. To help pacify the region he was given charge of Rome's military presence along the Rhine, with the XVII, XVIII and XIX legions placed under his command together with their supporting auxiliary cavalry and infantry. The eight other legions that had previously been campaigning along the Rhine frontier had by this time been redeployed to the Balkans to deal with a revolt, though the emperor felt the three remaining legions were easily enough for what should have been a mopping-up operation. Augustus could not have been more wrong.

Initially Varus' posting went well, with a thriving cross-border trade developing which saw the German tribes supplying cattle, food, iron and slaves in exchange for Roman currency and luxury goods. Indeed, some of the tribes pledged their allegiance to Rome, with large numbers of German warriors joining the ranks of the Roman *auxilia*. Meanwhile, many young German aristocrats were sent to Rome as hostages to ensure the on-going good behaviour of their respective tribes. While there they were well treated, and often given a Roman education.

One such individual benefiting from this exchange was Arminius, son of Segimerus, the senior chieftain of the Cherusci tribe. On his return from Rome Arminius then joined the staff of Varus, to whom he became a trusted advisor. However, by this time Varus had started to live up to his reputation as a hard taskmaster, using martial law to deal with any German tribesmen who refused to bow to the might of Rome. Soon relations with the Germans began to break down, with Arminius deciding to betray Varus and secretly forging an anti-Roman alliance among the usually fractious German tribes including the Cherusci, Chatti, Marsi and Bructeri. These now responded to Roman provocation by rising up against Varus, who in AD 9 decided to lead in person a large-scale punitive expedition into German territory featuring all three legions and most of his *auxilia*. His aim here was to deal with the German threat once and for all. However, his legionary spearheads were led deep into the German forests by Arminius and his other German advisors where, at pre-arranged points, they were ambushed. In a series of increasingly desperate engagements the legionaries and *auxilia* were then systematically wiped out. This shattering defeat was a desperate shock for the Romans, with a traumatised Augustus repeatedly hitting his head against the palace walls on the Palatine hill in Rome when he heard the news, famously shouting 'Quintilius Varus, give me back my legions!'

Here and overleaf we see two centurions of Varus' ill-fated expedition. That on the left was painted by Graham for the *muli mariani* ('Marius' Mules') exhibition at the Kalkriese Museum in Germany in 2019, and is used here by the kind permission of Thomas Kurtz (Kalkriese being the location of one of the principal engagements of the Varian disaster). The

image shows a highly decorated centurion, and was inspired by the sepulchral monument of Marcus Caelius who died in the debacle. The exaggerated feathered transverse crest is copied from a monument to Marcus Petronius Classicus, this originally found in the former legionary fortress of Poetovium in Slovenia, now the modern town of Ptuj.

Meanwhile, the second reconstruction (below) is of the senior centurion Marcus Caelius who also died in the disaster. Caelius is depicted as he appears on his funerary monument, now in the Rheinisches Landes Museum in Bonn but found originally near the legionary fortress of Xanten. Tellingly, Caelius' bones were not recovered. His cloak as shown here is based on Egyptian funerary portraits of Roman soldiers which suggest that centurions may have worn a particular type of blue cloak called a *paludamentum*, this worn draped over the left shoulder and the left arm. He wears many awards, including *armillae*, torques and *phalerae*, all showing his seniority and length of service. On his head he also wears a *corona civica* civic crown, this formed from a chaplet of oak leaves and awarded for extreme valour, usually involving the saving of a fellow citizen's life. He also carries a gilded *vitas* vine stick.

THE EARLY EMPIRE: AUGUSTUS TO TIBERIUS

EARLY PRINCIPATE LEGIONARIES

HERE WE SEE A GROUP of three legionaries at the time of the Varian disaster, with a classic early Principate *miles* (below) on the march with his pack very evident, justifying the nickname Marius' Mules. This image was also painted for the exhibition at Kalkriese Museum. Graham's very detailed painting shows the personal kit of the late Republic and Principate legionary, most of it carried here on the T-shaped pole held in his right hand. This would normally rest on his shoulder when on the march. The legionary's bulkiest load was his *scutum* held in place across the back, while his helmet is shown strung from his neck across his chest. His marching kit also includes a *paenula*, the hooded bad-weather cloak made from thick wool and fastened with a button or toggle. Meanwhile, very important for this legionary were his hobnailed *caligae* sandals. Typically these featured a leather upper made from a single leather piece that was sewn at the heel. This was then stitched to a multiple-layer hide sole shod with many iron studs, each sandal weighing up to 1kg.

From the time of the Marian reforms each legionary was also a skilled engineer in his own right, with building and engineering a key part of his daily life. To enable the troopers to fulfill such a role they also carried a stake (used to create marching camp palisades and caltrops), saw, pickaxe, chain, sickle, basket and leather strap. Finally, the legionaries of the period also carried a sturdy cross-braced satchel for their personal effects, a waterskin in a net bag, a *patera* bronze mess tin, a cooking pot, canvas bags for grain rations, spare clothing, and bespoke engineering equipment.

Meanwhile, the legionary at right is shown wearing an early form of *lorica segmentata*, the classic banded iron armour so often associated with legionaries of the Principate. This particular panoply is based on a set of armour recently discovered near Kalkriese which, when complete, would have weighed around 8kg, making it about half as heavy as the *lorica hamata* chainmail hauberks it largely replaced. *Lorica segmentata* was unique amongst the standard panoply of the Roman legionary in that it was designed indigenously rather than being a Roman adaptation of the equipment of their opponents. Appearing in the later first century BC and remaining in general use until the later third century AD, *lorica segmentata* may have originally been a type of gladiator armour. In addition to the fine protection provided by the articulated shoulder and thorax plates and bands, it was cheaper and quicker to make than *lorica hamata* and *lorica squamata*, though because of the number of complex hinges and straps it proved complex to maintain in the field.

Lorica segmentata was at its most sophisticated early in its use, the armour-type gradually becoming less and less complex over time, though with a corresponding decline in flexibility. The evolutionary sequence described for *lorica segmentata* reflects this, with the key variants (all named after the location where examples were found) being as follows:

- The Dangestetten–Kalkriese–Vindonissa type, those found dating to between 9 BC and AD 43.

- The Corbridge–Carnumtum type, those found dating to between AD 69 and 100.

- The Newstead type, those found dating to between AD 164 and 180.

Each is notably less complicated than that which preceded it with, for example, that found in the *principia* of the vexillation fort at Newstead (Roman Trimontium) in the Scottish Borders in 1905 featuring rivets to replace earlier bronze hinges, a single large girdle plate to replace the two previous ones, and hooks to replace earlier and more complicated belt-buckle fastenings. The finding of the new *lorica segmentata* hauberk at Kalkriese proves this point, this an early version featuring very high levels of craftsmanship missing from later types.

THE EARLY EMPIRE: AUGUSTUS TO TIBERIUS

The final figure (left) with raised *pilum* in *lorica segmentata* is a reworked original reproduced with the kind permission of Osprey Publishing, and also represents a casualty of the Varian disaster. Note that his Imperial 'Gallic' helmet, though still showing its La Tène origins in Gaul, had by this time evolved into a very sophisticated piece of military technology. This included the addition of the protecting iron bar across the brow ridge to deflect slashing blows aimed at the scalp, and the sloped neck guard with ribbing at the nape. Later developments included projecting ear guards.

LEGIONARY OF THE VARIAN CAMPAIGN IN EARLIER PANOPLY

HERE WE SEE ANOTHER IMAGE from the Kalkriese exhibition, another legionary of the Varian disaster who is shown wearing earlier style *lorica hamata* armour. While *lorica segmentata* was by this time the predominant type of thorax protection worn by the legionary, mail hauberks still remained in use among the rank and file, and were also particularly favoured by Principate officers and standard bearers.

The Early Empire: Augustus to Tiberius

Early Principate Legate

This further image from the Kalkriese exhibition shows a senatorial-level *legatus legionis* of the early Principate. In terms of command structure, the legate was the senior officer of the legion, directly appointed by the emperor. His second-in-command was also of senatorial level, called the *tribunus laticlavius*, a younger man gaining the experience needed to command his own legion in the future. Third in command was the *praefectus castrorum* (camp prefect), a seasoned former centurion responsible for administration and logistics. Below this level there were five younger equestrian-level tribunes, called the *tribuni angusticlavii*, these being allocated tasks and responsibilities as necessary. Actual control of each cohort in the legion was then the responsibility of the centurions (six to a normal cohort), these all having specific titles reflecting their seniority based on the old manipular legions of the Camillan and Polybian periods. These names, with seniority in ascending order, were:

- *hastatus posterior*
- *hastatus prior*
- *princeps posterior*
- *princeps prior*
- *pilus posterior*
- *pilus prior*

Graham has based this image of a legate of the time of the Varian disaster on the many statues surviving from this period, many depicted wearing armour. In this case the legionary commander wears a fine quality muscled cuirass. The tied cloth band around the chest and his senatorial boots are overt marks of his rank, setting him apart from the more junior officers in his legion.

ROMAN WARRIORS

The Early Empire: Augustus to Tiberius

Rhineland Legionaries

Two senior legionaries as depicted on early Principate sculptures found in the Rhineland region of modern Germany, shown here in their dress-down kit.

The figure at left is based on the tombstone of C. Petillius Secundus of *legio* XV *Primigenia*, found in Bonn. He wears a *paenula* cloak with two round *fibulae* brooches and two wooden toggle fasteners. The most common colour for Roman legionary cloaks, as depicted in mosaics and paintings of the period, is a yellow brown which suggests they were un-dyed and retained the natural lanolin of the wool to help keep them waterproof. Beneath the cloak the legionary is wearing a woollen scarf and an elaborately draped tunic, suggesting it was made from either very fine wool or linen.

Meanwhile, the figure on the right is based on the tombstone of P. Flavoleius Cordus of *legio* XIV *Gemina* found during excavations of the legionary fortress at Mainz. He also wears a *paenula*, though this time fastened on the right shoulder with a brooch in the eastern manner. The cloak is draped over the left shoulder and has spherical decorations on the lower edges. The fact that Cordus carries a scroll and perhaps wax writing tablets, or as shown here a leather case for tablets tucked into a *fascia ventralis* waistband, indicates he was a *beneficiarii* seconded to the staff of the *legatus legionis*, or even the provincial governor or procurator. To reflect this status, Graham here depicts Cordus wearing a particularly fine blue cloak to set him apart from his fellow legionaries. Both Cordus and Secundus wear 'Mainz' type *caligae*, but of different designs.

EARLY PRINCIPATE AUXILIARIES

Here we see two figures painted by Graham in 2020 for a permanent exhibition at the Bad Kreuznach Museum in Germany, shown here with its kind permission. The figure at left is an auxiliary infantryman based on a tombstone on display in the museum. He is called Annaius Daverzus and is shown here ready for action in his auxiliary *lorica hamata* mail hauberk, this remaining the standard armour for auxiliaries throughout the Principate. His auxiliary shield is an unusual rectangular design which covered the torso and featured a central iron or bronze boss, a less complex design than the curved legionary *scutum*. *Auxilia* helmets were also less sophisticated, often being cheaper bronze versions of those worn by the legionaries. *Auxilia* were armed with short, throwable spears called *lancea* rather than *pila*, and a sword similar to the legionary *gladius*, though this was later replaced by the longer cavalry-style *spatha*.

Auxilia infantry formations in the Principate were based on a single quingenary cohort of 480 troops, or a double-sized milliary cohort of 800 troops. These cohorts (both the small and large) were divided into centuries of between 80 and 100 men, these under the command of a centurion and clearly replicating the similar structure in a legionary formation. However the centurions, unlike the auxiliary troopers, were sometimes Roman citizens appointed from the legions, setting them apart from their rank and file who were recruited from native communities and only gained citizenship on their retirement after twenty-five years' service.

The second figure (right) is an auxiliary archer based on the tombstone of a bowman called Hyperanor who served in *cohors* I *sagittariorum*. His monument, found at Bingerbrück, is particularly impressive and measures 2m by 0.7m. His high quality *gladius* scabbard features additional disc decoration that Graham describes as 'simply bling over bling'.

The Early Empire: Augustus to Tiberius

Roman archers fought using a composite bow based on those of the horsemen of the Asian steppe, made from laminated layers of wood, bone, horn and sinew. This gave the weapon much greater penetrating power than the self-bow used by less sophisticated opponents. Further, notched stiffeners at each end of the bow, and its handgrip, gave the bowstring greater leverage. This kept the weapon from bucking when fired, which increased accuracy.

Roman arrows also featured sophisticated technology, with different arrowheads used depending on the opponent engaged. Against unarmoured enemies, for example the majority of German and Gothic foot troops, a broad arrowhead was used to maximise damage to the opponent's body. Meanwhile, against more heavily armoured troop, such as Sarmatian lancers and Parthian cataphracts, a much narrower bodkin-point arrowhead was used, this causing less damage to flesh but able to penetrate armour. Other specialist arrowheads included those designed for use in a siege which featured an iron basket behind the arrow tip, designed to carry lit flammable material.

Roman arrow shafts were made of wood, reed or cane depending on where they were manufactured. The arrowhead was set in place with a wooden pile to ensure the arrowhead didn't shatter on impact. The arrows were carried in a *pharetra* quiver held between the shoulder blades by leather straps. Auxiliary archers also had bracers on their left wrists to protect them from the kick of the bowstring when firing. They also had either leather finger guards or a metal thumb ring to enable them to pull the bowstring rapidly. For self-defence they carried a standard auxiliary sword.

Roman Warriors

The Early Empire: Augustus to Tiberius

Auxiliary Light Troops of the Early Principate

Two more auxiliary light troopers, both also painted for the exhibition in the Kalkriese museum, with the first a slinger whose appearance is based on a depiction on Trajan's Column. Slingers remained popular among Roman auxiliary units throughout the Principate phase of empire, this a weapon particularly favoured during sieges when a bombardment of slingshots was often used (alongside artillery fire) to keep the heads of defenders down on parapets while legionaries and other *auxilia* stormed the walls and gateways.

Meanwhile, the second figure is another auxiliary archer very similar to that detailed in the previous caption, though this time lacking the *bracae* and leg wrappings. Once more this seemingly lower grade auxiliary carries a high quality *gladius*, and additionally a *pugio* dagger. Graham is keen to emphasise in his artwork the quality of these side arms, perhaps indicating that these bowmen on the northern frontier were actually of higher status among the auxiliaries based there than previously thought.

The Roman Fort and Harbour at Velsen

Graham's highly detailed reconstruction of the Roman fort and fortified harbour at Velsen (Roman Flevum) on the Rhine Delta in the modern Netherlands. The original fortification here was built by Augustus when campaigning against the native Frisii. This image was created for the book *Edge of Empire* by Jona Lendering and Arjen Bosman and is reproduced here with their kind permission. Visible in the foreground on the quayside and in the river are the *myoparo* and *scapha* cutters and skiffs which were two of the principal vessels used by the squadrons of the *Classis Germanica* regional fleet based here, alongside *liburnae* bireme war galleys. *(illustration overleaf)*

CHAPTER 4
CLAUDIUS TO HADRIAN

'We artists have to be selfish you know. We have to save ourselves.
After all with each painting we die a little.'
ANTON MAUVE, *LUST FOR LIFE*, 1956.

THREE LEGIONARIES IN FATIGUE CLOTHING

THREE LEGIONARIES IN FATIGUES BASED on figures detailed on Trajan's Column. Each wears a *tunica* with their twin coloured stripe patterns based on examples found in archaeological excavations in Egypt, though the meaning, if any, of each shade is lost to us.

The *tunica* was standard attire for men across the the Roman Empire, with the type of fabric used a key indicator of status. Slaves and poorer freedmen (manumitted slaves) wore a simple *tunica* made of un-dyed, rough wool that was often unbelted. Those worn by middle and upper-class citizens (including soldiers) were fabricated with softer wool, and in the east cotton also, as with those illustrated here. These finer *tunicae* were always belted as a mark of status.

The *tunica* was shaped like an upside-down sack with holes for the head and arms, the belt (if worn) then securing it as a comfortable garment. Here two of the legionaries are on construction duty, one with his *tunica* fastened over one shoulder, a practical fashion called *exomis*. This allowed much more freedom of movement. Meanwhile, the grimacing central figure carrying the *decempeda*, a graduated measuring rod of 10 Roman feet, is on punishment duty. He holds the implement with his outstretched right arm, this clearly causing him distress indicating he has been standing in this position for some time, and lacks a belt around his *tunica* as a mark of shame.

Claudius to Hadrian

ROMAN WARRIORS

The 'Moaning Marine'

GRAHAM FREQUENTLY BASES THE FIGURES he paints on real individuals, and here is a prime example. This is Claudius Terentianus, a marine of the *Classis Alexandrina Augusta*, the Egypt-based regional fleet that patrolled the south-eastern Mediterranean, River Nile and Red Sea.

The regional navies of the Principate Empire were the result of the military reforms of Augustus, as with his restructured legions detailed above. Before this date the fleets of the Republic were *ad hoc* in nature, designed to fight symmetrical engagements against opponents including Carthage, the Hellenistic kingdoms and in the Roman civil wars across the Mediterranean. Augustus rationalised this system, re-creating the various fleets he inherited as the last man standing of the civil wars into regional navies that reflected the empire's expanding geographical reach. By the end of the first century AD there were ten such fleets, each with a specific area of territorial responsibility. The *Classis Alexandrina Augusta* was one of the first created by Augustus, in the later 20s BC. It received its imperial *cognomen* after supporting Vespasian in AD 69, the 'Year of the Four Emperors'.

By the time of the Principate Empire most of the warships in the regional fleets were nimble liburnian bireme galleys. Their fighting crew was made up of marines, who were equipped in a similar manner to principate auxiliaries. They had specific names based on their given specialisations, for example *ballistarii* artillery crew, *sagittarii* archers and *propugnatores* deck soldiers.

We know a great deal about Terentianus thanks to the archive of his father Claudius Tiberianus. This is a collection of letters written in Greek and Latin on papyrus discovered beneath the stairway of a fine house in Karanis, then a Ptolemaic agricultural town located in the north-east corner of the city of Faiyum in middle Egypt. The letters give a fascinating insight into the daily life, business and military affairs of Tiberianus' family. Those written in Latin have proved particularly useful to papyrologists because of the light they shed on the use of *sermo plebeius* (everyday 'vulgar Latin') in military circles in Roman Egypt.

The letters of Terentianus to Tiberianus are equally interesting, given that he always seems to be wanting his father to send him something or get him promoted to a legion, hence the modern nickname 'moaning marine'. For example, in various letters he asks for a beaver skin cape, a *pallium* cloak, *bracae* trousers, socks and *caligae* boots. He also requests more overtly military items be sent, including a new sword, pickaxes, grapnel and spears. The last are particularly interesting for the insight they give regarding the quality of the standard equipment Terentianus was being issued with if he thought it necessary to request better-quality replacements from his family.

Trajanic Egyptian Decurion

THE SOLDIER SHOWN IS BASED on textile finds from the vast Roman granodiorite quarries at Mons Claudianus in the eastern Egyptian desert, these dating to the reign of Hadrian.

Of particular interest among the artefacts excavated there was this style of cap. Pillbox type headwear is usually associated with the later Dominate Empire, hence the alternate name tetrarchic cap. Yet this example found at the site, and in a particularly good state of preservation, has been firmly dated to the time of Hadrian. It is very rare that Roman monuments show anyone, let alone soldiers, wearing hats at this period and so Graham has incorporated it into his image.

The soldier might be Marcus Caninus, a decurion mentioned on an *ostraca* pot sherd found at Mons Claudianus. A decurion was a cavalry officer, roughly equivalent to an infantry centurion, in charge of a troop of thirty cavalrymen. A cavalry unit called the *ala Apriana* is attested at the site in AD 108. Sadly no image of Caninus exists.

Claudius to Hadrian

Centurion Marcus Favonius Facilis

Marcus Favonius Facilis is one of Roman Britain's best-known soldiers. This centurion was based in the early provincial capital of Colchester (Roman Colonia Claudia Victricensis) where his life was commemorated with a fine tombstone. This was found in the cemetery on the western side of the *colonia* to the east of the modern Beverley Road. When excavated in 1868 it lay in two portions, both less than 1m below the surface.

Interestingly, the sculpture of Favonius is hardly weathered, leading some to argue it was set up in his memory in the AD 50s and then toppled and broken during the sacking of the town early in the Boudiccan revolt in 60/61.

The Latin inscription on the tombstone is typically descriptive and reads:

> Marcus Favonius Facilis, son of Marcus, of the Pollian voting-tribe, centurion of the XXth (Valeria Victrix) legion, lies buried here; Verecundus and Novicius, his freedmen, set this up.

It is not clear from this narrative if Favonius had retired from the legion and was now a veteran resident in the *colonia*, though the reference to his freedmen may indicate the latter given their local Brythonic names. That being the case, Favonius may have been a veteran of the Claudian invasion of Britain in AD 43.

When the tombstone was excavated a cylindrical lead container some 33cm high and 23cm in diameter was found containing a cremation burial; this is usually described as that of Favonius. From these remains archaeologists have determined that he was missing a front tooth, hence Graham's enigmatic representation. Meanwhile, detailed examination of his image on the tombstone has revealed another interesting observation, namely his lack of any decorations for his service. This reflects the very wide range of centurion ranks within a legion in terms of seniority – there were around sixty centurions in each legion during this period. That being the case, despite his fine memorial, this indicates Favonius was either at the lower end of the rank scale, or was instead employed on non-combatant activities, for example as a *beneficiarius*.

Soldier of legio II Augusta, based at Caerleon

Here Graham has recorded in one wonderful image much of the legionary panoply found in the archaeological record at Caerleon near Newport in south-eastern Wales, the legionary fortress that was home to *legio* II *Augusta* from the AD 70s through to the early fourth century at least.

This elite legion may have been founded by Julius Caesar in the later stages of his civil wars around 48 BC, in which case it fought with him at the Battle of Munda in Spain in 45 BC, though its actual origins remain obscure. Our first secure detail in the historical record places it in northern Spain after 26 BC when it was one of the seven legions deployed by Augustus in his Cantabrian campaigns there. Its exemplary performance during this conflict may have been the reason it was given the *cognomen* Augusta.

The legion was then one of the four crack legions that formed the main strike force of the Claudian invasion of Britain under Aulus Plautius in AD 43, remaining there until almost the end of its existence. It is last mentioned in the *Notitia Dignitatum*, a late fourth/early fifth century list of military offices, and was by that time based at the Saxon Shore fort at Richborough on the east Kent coast.

Here Graham's legionary wears classic Principate military attire, though most notably his boots are fully enclosed *calcei* rather than the more usual strapped *caligae*. These were mid-weight outdoor walking boots with a flat sole covered in the usual hobnails. However, unlike the more common legionary *caligae*, these boots entirely covered the foot and ankle up to the lower shin. They were secured using crossed laces or thongs. Their use here, based on archaeological evidence from Caerleon, indicates that the soldiers themselves may have been sourcing their own footwear from civilian cobblers operating in the legionary fortress *canaba*, these being more suitable for wear in the north-west of the empire.

CLAUDIUS TO HADRIAN

ROMAN WARRIORS

Auxiliary Trooper of the Early Empire

THIS FIGURE REPRESENTS A CLASSIC Principate auxiliary infantryman, wearing the panoply in which they are frequently depicted everywhere across the empire, in this case on Trajan's Column. Though *auxilia* were full line of battle troops, they were the junior partners to their legionary counterparts. Foot troops were paid 100 *denarii* per annum from the later first century AD, with cavalry paid 200 *denarii* (those based on the wing of a battle formation being paid 333 *denarii*). Terms of service were similar to those of the legionaries, with auxiliaries normally serving twenty-five years. On retirement the trooper was given a diploma that granted Roman citizenship to himself and his heirs, the right of legal marriage to a non-citizen woman, and citizenship for any existing children.

CENTURION BERATING HIS SERVANT, CHESTER

WHEN WITHIN THEIR LEGIONARY FORTRESS, each century in the legion was broken down into ten eight-man sections called *contubernia* who shared two barrack-block rooms, with their centurions having their own individual houses at the end of the barrack block. Here we see a particularly fine example in the initial stage of the legionary fortress in Chester (Roman Deva Victrix) in an image painted by Graham in 1982 for the Grosvenor Museum there.

The legionary fort at Chester, even in its earliest stage, was a particularly large example built with timber ramparts in the later AD 70s by *legio* II *Adiutrix* on the banks of the River Dee. This gave it easy access to the Irish Sea and the northern coast of Wales and was a particularly good location because it sat deep within the lands of the native Cornovii and also bordered the broad territories of the Brigantes to the north and east and the Deceangli and Ordovices in Wales to the west.

Legio II *Adiutrix*, its *cognomen* meaning 'Rescuer', was founded in AD 70 by the new Emperor Vespasian from marines of the *Classis Ravennatis* Adriatic regional fleet after they supported his bid for the imperial throne in 69. Its first assignment was to help put down the Batavian Revolt in the Rhine Delta, after which it was redeployed to Britain in 71 with the province's new governor Quintus Petillius Cerialis. It was recalled to the continent in 87 to participate in Domitian's Dacian campaigns.

Here we see a senior centurion of the legion berating his servant, almost certainly a freedman, for not cleaning his helmet with its fine traverse crest well enough. The centurion wears classic *lorica hamata* mail, with his room notable for the *lares* household deity in the small alcove on the wall to the left and the painted decoration (based on fragments of plaster found during excavations).

Roman Warriors

NERO'S NAVAL ASSASSINS

NERO, LAST OF THE JULIO-CLAUDIAN emperors, was called by many the mad emperor because of his often bizarre behavior. The matricide of his mother Agrippina the Younger in AD 59 is a prime example, though the reasons behind it are not fully understood. According to Tacitus, Nero's affair with Poppaea Sabina was the trigger behind the dramatic falling out as she was already married to the leading Senator and future short-lived emperor Otho. In that context, the affair could therefore have put the imperial family at risk. Additionally, Agrippina was also fond of Nero's then wife Octavia.

Nero's attempts to murder his mother were outlandish to say the least, with Suetonius saying that the emperor had his freedman Anicetus arrange a shipwreck to kill her using a collapsing boat. However Agrippina, a good swimmer, survived and swam ashore, though her survival was to no avail as she was later executed by Anicetus, a former slave of Nero's. He stabbed her to death in her villa, but then reported her death as a suicide.

Here we see two of the protagonists, Anicetus himself and a naval centurion, both of the *Classis Misenatis* Tyrrhenian regional fleet which was based at the major naval base of Misenum on the north-western tip of the Bay of Naples. Anicetus had an unusual career, having been the young emperor's tutor, likely the reason for his manumission. After this he was promoted through the ranks of the imperial hierarchy and eventually made the *praefectus classis* (admiral) of the Tyrrhenian fleet. This proved the high point of his career as, after the murder of Agrippina, Nero forced him to confess to committing adultery with Octavia, after which she was banished and later died a miserable death. Anicetus himself was banished to Sardinia where he lived out his days in comfortable exile before dying of old age.

Ambush at Beth Horon

THE ROMANS FOUGHT THREE JEWISH rebellions in the first and second centuries AD, each testing the empire's military capability to its extreme limit. The First 'Great' Jewish Revolt broke out in AD 66. It originated with local complaints against religious intolerance and then escalated into anti-taxation protests. Soon Roman citizens in Judaea were being attacked, with the empire responding by plundering the Temple in Jerusalem and executing 6,000 Jewish captives. This prompted a full rebellion, with the Roman garrison being overrun and the Roman officials in Jerusalem fleeing. The Roman commander in Syria, Cestius Gallus, then led an army featuring *legio* XII *Fulminata* and large numbers of auxiliary units into Judaea to put the rebellion down. However, this was ambushed and defeated by Jewish rebels at the Battle of Beth Horon, with 6,000 Romans killed and the legionary *aquila* standard lost. This event shocked the Roman world and the emperor Nero responded by putting together a large army with four legions, auxiliary units and regional allied troops. He appointed the soon to be emperor Vespasian as its commander, this veteran of the Claudian conquests of Britain then appointing his son Titus (also a future emperor) as his main general. In AD 67 Vespasian invaded Galilee, in the first instance targeting the regional Jewish strongholds there. However, Vespasian soon returned to Rome when news of Nero's death reached him in 69, and it was Titus who finally besieged Jerusalem in 70. By this time the city was packed with thousands of rebels who had fled the Roman depredations in Galilee. These were now deployed to defend the city's three impressive wall circuits. The first two were breached in the first three weeks of the siege. However, a stubborn stand prevented the Romans from breaking through Jerusalem's third and thickest wall, it taking a further three months finally to force a breach. This resulted in a massacre of Jewish warriors and the burning of the Temple there, its treasures being carried to Rome where they formed the centrepiece of Titus' triumph (as is recorded on his arch in the Forum Romanum). After the fall of Jerusalem, *legio* X *Fretensis* then carried out a regional mopping-up operation, finally capturing the Jewish stronghold of Masada in 73/74.

Here we see the very beginning of this bloody war, with Roman auxiliary cavalry in jeopardy during the ambush at Beth Horon. These were usually organised into quingenary *alae* of 512 men or milliary *alae* of 768, each commanded by a *praefectus alae*. Such basic cavalrymen were called *equites*, with their defensive panoply as shown here featuring flat oval (or sometimes hexagonal) shields, short *lorica hamata* hauberks and a variety of types of bronze and iron helmets, often with cheek and neck guards. The fine design with the silvered braiding shown on the first warrior here is based on an example found at Weller in Luxembourg, while that worn by the second figure which features a crest is based on one found at Ely in the UK. For offensive weaponry, *equites* were equipped with a *hasta* spear as carried by the rear figure here that could be thrown or used as a short lance, and a *spatha* long sword as wielded by the first cavalryman. Though many *equites* armed in this way were among the most feared units in the Principate military, here such a martial reputation was to no avail given the scale of the Roman defeat.

Siege of Gamla

GAMLA, AN ANCIENT JEWISH CITY on the Golan Heights, was originally founded as a Seleucid fort during the Syrian Wars against Ptolemaic Egypt. It later became a fortified city under Hasmonean rule from 81 BC.

During the First Jewish Revolt the city was initially loyal to Rome, though later joined the rebellion after becoming crowded with refugees fleeing the savage Roman offensive after their loss at Beth Horon. It then sustained two sieges, the first in later AD 66 led by Herod Agrippa II, and the second by 60,000 Roman legionaries (from *legio* X *Fretensis*, *legio* XV *Apollinaris* and *legio* V *Macedonica* among others) and *auxilia* under Vespasian from October 67. The defenders only numbered 9,000 according to Josephus who actually participated in the city's defence, though even this figure was likely an exaggeration. During the second siege, at first the Romans tried to take the city using a siege ramp, but were repulsed. Only on their second attempt did they succeed in breaching the walls in three different locations which then gave them access to the urban interior. There they engaged the Jewish defenders in brutal hand-to-hand combat up the steep hillsides of the city where, fighting in the cramped streets, the legionaries had to defend themselves from a barrage of rocks and other missiles from the rooftops. Given the number of defenders crowding onto the roofs many collapsed, bringing the supporting walls down, too. Not only did this crush the defenders but also many attacking Romans since much of the debris fell into the street. This forced the Romans to retreat, though they re-entered the town a few days later and eventually destroyed the last remaining redoubts of Jewish resistance.

In this image Graham has painted a legionary during the second Roman-led assault on the town as he struggles up the steep streets under constant bombardment from the Jewish defenders above. One such legionary was indeed later crushed under a collapsing roof and wall: his skeleton with its *lorica segmentata* and bronze helmet was later recovered during archaeological excavations in Gamla.

Roman Warriors

The Leather Armour Debate

TWO ROMAN LEGIONARIES, BOTH BASED on the same tombstone sculpture of Gaius Valerius Crispus, a trooper of *legio* VIII *Augusta*, found in Wiesbaden in the western German state of Hesse. The first is based on nineteenth-century research later developed by Raffaele D'Amato and is a literal interpretation of his cuirass which shows the actual detail on the tombstone representation. This has Valerius wearing a tanned leather suit of armour fitting closely to his body with large protective shoulder guards and semi-rigid leather breeches. These are called *feminalia* and featured layered strips of leather much like classic *pteruges*, though this time fashioned into short trousers rather than a skirt. A life-size replica of a legionary wearing this panoply was for many years a key feature of the Roman collection in the Römisch-Germanisches Zentralmuseum in Mainz. Many generations of wargamers, figure collectors and modellers will also be familiar with this replica since it formed the basis of the famous Airfix Roman set of 1/72-scale figures.

Because many modern scholars believe leather was both impractical and less useful as armour, Graham's second interpretation of the image is more conventional in style. Here he suggests the lack of detail on the sculpture's torso is because, when completed, the figure had *lorica hamata* mail armour represented by paint. In this version Valerius has a mixture of old and recent equipment, showing how some older styles were retained if they were still serviceable. For example, his helmet is a traditional Montefortino-Buggenum type, a style seen in the later years of the Republic. Meanwhile, instead of the leather shorts, this feature has been re-interpreted here as *pteruges* attached to a *subarmalis* underneath the mail shirt.

Sunset in the Lands of the Deceangli

One of Graham's better-known images, here we have an auxiliary *eques* in northern Wales during the campaigns in the early AD 60s of the great warrior governor Gaius Suetonius Paulinus, immediately prior to the Boudiccan Revolt. His helmet is similar to that worn by one of the figures in the earlier illustration of the ambush at Beth Horon, with the silvered braiding again based on the example found at Weller in Luxembourg.

Graham has illustrated the *eques* with an expensively coloured green saddlecloth. Achieving this tone required double dyeing which was very expensive, the fine saddlecloth therefore reflecting the high status of the cavalry among the *auxilia*. This specific colour is based on a first-century AD cavalry tombstone from Germany, and third-century wall paintings from Luxor in Egypt.

LEGIONARY FORTRESS AT INCHTUTHIL

THE LARGE LEGIONARY FORTRESS AT Inchtuthil on the River Tay was founded in AD 83 by *legio* XX *Valeria Victrix* as part of the warrior governor Gnaeus Julius Agricola's later campaigns of conquest in Scotland, though was soon abandoned and systematically demolished from 86 when the Roman troops there were withdrawn from the far north after Domitian recalled Agricola. It occupied a fine position on a natural platform overlooking the Tay, on its northern bank south-west of Blairgowrie in Perth and Kinross, this enabling the Romans to control access to the river's upper valley and so securing the logistics support needed as Agricola's legionary spearheads drove deeper into the far north.

Inchtuthil was typical of earthen bank and timber-built fortification of this size, its defences featuring a single large ditch 7m wide and 2m deep and a large turf wall carrying the timber rampart. The interior of the fort covered an area of 21.5ha, with its four gateways also constructed of timber, each with twin portals recessed between two towers.

The fort's internal buildings included the *principia* headquarters, *praetorium* commanding officer's house, sixty-four standard barracks buildings, six granaries, store sheds and a large military hospital, a drill hall and a small *fabrica* industrial unit. Not all of its interior structure was completed before it was abandoned as part of the gradual withdrawal of Roman forces from the far north to the later line of Hadrian's Wall.

In this image, painted for the Gask Ridge Project in consultation with its directors Dr David John Woolliscroft and Dr Birgitta Hoffmann, Graham has included at upper right the part-finished *macellum* indoor market that would have been a key feature of the fort's *canaba* civilian settlement if the whole site had been completed.

The Hero of Herculaneum

ONE OF THE MOST FAMOUS finds in recent excavations at Herculaneum, the up-market Roman coastal town at the foot of Mount Vesuvius on the Bay of Naples, were the human remains of a marine of the *Classis Misenatis*. He was found in the boat sheds on the seafront where he perished, sheltering there with many others as the town was enshrouded by wave after wave of pyroclastic flows of superheated ash in the AD 79 Plinian eruption that devastated the region.

When his skeleton was excavated the remains of his knapsack were also recovered, this containing a wide variety of carpentry tools including chisels and a small iron hammer. These led initially to his identification as a *faber navalis*, the officer responsible for specialist engineering and carpentry aboard a Roman warship. Most recently, re-analysis of other finds on the body, including his leather belt decorated with silver and gold, and a large collection of coins including twelve silver *denarii*, has led to the suggestion he was a senior officer, perhaps sent to help oversee the failed evacuation of the seaside town.

In Graham's fine image he has portrayed the marine in a *sagum* cloak and a high quality *tunica*, both speculative although traces of red-orange wool were found on the skeleton.

Claudius to Hadrian

An *Eques Dromedarius* on the Desert Frontier

As the Principate phase of empire progressed a variety of new types of *equites* appeared in the ranks of the *auxilia*. In the east these included *equites dromedarii*, camel-mounted troops who were particularly suited to patrolling the arid desert *limes* there.

They initially appeared in the province of Arabia Petraea to the south of modern Syria, this largely a desert inhabited by nomadic and transhumant Arab peoples. For commerce this region relied on desert caravans operating through trading centres such as Petra, a town annexed by Trajan during his eastern campaigns which initiated the creation of the province. One legion was based here, *legio* III *Cyrenaica* at Bosra (Roman Bostra), which was also the provincial capital. From here the legionaries and their supporting *auxilia* including the *equites dromedarii* had the unforgiving task of manning the southern limes Arabicus. Defence-in-depth is evident here, with the Romans frequently making use of their Ghassanid Arab allies to repel the Lakhmid Arabs who were supporters of the Parthians and later the Sassanid Persians.

Camel-riding *equites dromedarii* were also found in Aegyptus, one of the powerhouse provinces of the Empire, established in 30 BC after the then Octavian and his general Marcus Agrippa defeated Mark Antony and Cleopatra. Given its economic might, the province was always a place of difference within the empire, this based on the abundantly fertile Nile Valley that provided much of the grain supply to Rome and elsewhere across the Mediterranean. Aegyptus was also unique among Roman provinces in being considered the Emperor's own domain where he was styled as the successor to the preceding system of Pharaonic rule. Here the governor was given the title *praefectus augustalis*.

The legionary and *auxilia* presence in Aegyptus was deployed to counter the frequent native insurgencies in the province and also fought the nomadic Blemmye and Nobatae who lived in the desert between the Nile and Red Sea. Both of these, while not sophisticated opponents in terms of tactics and technology, often raided Roman Egypt in such numbers that they presented a real danger. The Romans countered this threat with a series of fortifications and watchtowers to protect the rich agricultural land in the Nile Valley. Most Blemmye and Nobatae warriors were unarmoured bowmen, often mounted on mules and donkeys, though they occasionally used elephants trained for war.

Graham's *eques dromedarius* shown here is typical of those employed patrolling the Egyptian *limes* and desert interior. He wears his *paenula* over his head to provide shade from the intense sun, while his other clothing has been adapted from the local garments worn by the natives of the region. These are based on finds from Mons Claudianus and Didymoi, both in Egypt.

INSUS, *EQUES* OF ALA AUGUSTA

THIS STRIKING IMAGE IS BASED on the tombstone of Insus, an *eques* of the *ala Augusta* auxiliary cavalry unit based in the north of occupied Britain in the later first century AD. The monument was found in 2005 during excavations in Aldcliffe Road in Lancaster and is now housed in Lancaster City Museum after careful conservation. The tombstone is more or less complete, though was broken into two large fragments and a number of smaller ones when found. The memorial inscription on the tombstone reads:

> To the shades of the dead, Insus son of Vodullus, a citizen of the Treveri, trooper of the ala Augusta ... Domitia (his heir) set this up.

It is now listed as RIB 3185 in the corpus of Roman inscriptions found in Britain.

The image of Insus on his tombstone is particularly striking because of its grisly nature: he holds the severed head of a native Briton in his right hand, re-created here by Graham in his painting. This isn't surprising given his origins among the Treveri, a Gallic Belgae tribe who inhabited the lower Moselle Valley. Headhunting was well known in the Gallic and Germanic Late Iron Age prior to the arrival of the Romans in Gaul, who viewed it on the scale carried out as a fascinating though disturbing practice. As an example, the first-century BC commentator Diodorus says:

> The Gauls cut off the heads of their enemies slain in battle and fasten them about the necks of their horses. They hand over the blood-stained spoils to their attendants to carry off as booty, while striking up a paean over them and singing a hymn of victory. They nail up the heads on their houses, just as hunters do when they have killed certain wild beasts. They embalm in cedar oil the heads of their most distinguished enemies and keep them carefully in a chest. These they display, with pride, to strangers, declaring that one of their ancestors, or his father, or the man himself, refused the offer of a large sum of money for this head. They say that some of them boast that they refused the weight of the head in gold.

Writing shortly afterwards, the Greek geographer, philosopher and historian Strabo echoed these views, adding that Roman travellers in Gaul had seen many such heads, so many in fact that eventually they got used to the sight. Today, most of the evidence of this practice comes from hillfort sites, particularly in boundary ditches and next to gateways where many of the crania found display weapon injuries. It is unclear if these were placed there deliberately, or were the casually discarded heads of decapitated lower class warriors.

The practice of headhunting among warriors in Roman service continued into the Principate Empire as troops supporting the legions were formalised by Augustus into the *auxilia*. In addition to the more recent find of Insus' tombstone, many other examples in sculpture also show the practice, with five detailed here.

In the first instance we have the Great Trajanic Frieze. This comprises slabs from a monument to Trajan's two Dacian campaigns of 101–2 and 105–6, later reused and visible today on the early fourth-century Arch of Constantine. On one panel spanning two of the slabs three auxiliaries stand with right arms raised presenting the heads of Dacians to Trajan. The style of their armour and shields indicates they are cavalry. Meanwhile another auxiliary, this time mounted, reaches down with his left hand to grasp the hair of a Dacian, his right hand holding a *spatha* ready to decapitate his opponent. Next, on Trajan's Column in Rome, one of the helical friezes shows the severed heads of two Dacians impaled on poles next to two auxiliary cavalrymen as nearby legionaries build a fort. Moving on, a gruesome scene is depicted on the Bridgeness Slab, the easternmost distance slab along the Antonine Wall which records the building of '4652' paces of the then northern frontier by men of the Caerleon-based legio II Augusta; this artefact is now in the National Museum of Scotland in Edinburgh. The inscription on the slab is flanked by scenes of victory, with that on the left showing an auxiliary cavalryman riding down four natives. One has been decapitated, with his headless body slumped forward in a seated position while his head falls to the ground. Meanwhile, on the Column of Marcus Aurelius in Rome which commemorates his victories in the Marcomannic Wars, one of the helical friezes (scene LXVI) shows the seated emperor listening to an advisor

while two auxiliaries to his left distract him by holding up severed German heads. Finally, another good example is the late first-century tombstone of the *eques* Aurelius Lucius found in Chester. This shows his groom holding up a severed head.

Aside from his ghastly war trophy, the tombstone image of Insus is also notable for his helmet which is unlike any other found on a Roman tomb in Britain. It features the usual round bowl but with a thick brim featuring twin parallel lines. Graham originally interpreted this as a Coolus type based on the arch of Orange. However, after consultation with Dr Jon Coulston, this has been revised and a helmet of Butzbach type is now shown. Note also the green *equites* saddlecloth once more, this emphasising Insus' status as a leading auxiliary cavalryman.

Roman Warriors

On a Hard March, the *Muli Mariani*

A FURTHER IMAGE PAINTED FOR the *muli mariani* exhibition at the Kalkriese Museum in Germany. Here Graham's image of the marching legionary looks every bit a Marius' mule. This figure formed part of a larger group of six figures on display at the museum, and is now a permament feature of the travelling exhibition. For detail on the equipment carried by this marching soldier, see page 47.

Building a Marching Camp

HERE A LEGIONARY IN FULL armour labours with his pick at the end of a hard day's march to help build his legion's marching camp. These temporary fortifications were a key feature of all Roman military campaigns, from the mid-Republican period through to the end of the Dominate period. Thus, in normal circumstances, at the end of each day in enemy territory the military force in question would build a marching camp by the labour of the legionaries and *auxilia*.

The marching camp was constructed in a few hours after the day's march ended, with the camps coming in a variety of sizes based on the mass of the force needing protection. The typology of such camps largely tracks that for permanent fortifications, excepting that, at their upper limits, they far outstripped their permanent counterparts in size, for example that at St Leonard's Hill in the Scottish Borders being a massive 70ha in size (the largest in Europe in the Roman Empire) because it was built to house the entire 50,000-man force in the first Severan invasion of the far north of Britain in 209.

While temporary by their very nature (such fortifications were abandoned and deliberately slighted after a few days' use), marching camps nevertheless required substantial amounts of trained military labour in their construction, as depicted with our pictured legionary. Always 'playing card' in shape, they usually featured a deep ditch between one and two metres wide, with the spoil then being used to create an internal rampart. Atop this ran a palisade created using the stakes the soldiers carried as part of their specialist engineering equipment, with a regular part of Roman military training being designed to enable the rapid raising of such fortifications. The palisade atop the rampart was either a continuous wooden barrier, or one created by the stakes being lashed together to form large caltrops. Meanwhile, the camps also featured various kinds of protected gateway to ensure their resilience against any aggressor. Within this barrier the camp would then be set out for the night, effectively re-creating the interior layout of a permanent Roman fortification.

Claudius to Hadrian

Mainz Legionaries

Two soldiers based on figures from the Mainz pedestal reliefs. If it is an accurate depiction this monument records many unusual features. The large dolphin motif on one of the soldiers' helmets depicted on the reliefs was long thought to be an artistic convention. However, a recent discovery near Leiden in the Netherlands confirmed the existence of just such a copper-alloy feature on a Roman helmet. In the foreground of Graham's illustration the legionary, possibly from *legio* I *Adiutrix*, in a fighting stance wears what appears to be an over-tunic rather than any form of armour. Maybe the armour is underneath. *Legio* I *Adiutrix* had originally been raised from former naval soldiers which might explain the dolphin motif. His companion is another legionary, this time from *legio* XIV *Gemina*, who appears to hold a slave chain and has no waist belt even though he wears a heavy mail shirt. It has long been thought that a waist belt would help to take the weight of a mail shirt off the shoulders. He also wears his *gladius* on his left hip contrary to how most legionaries of this period are depicted with swords on their right. This image was painted for an article by the eminent military archaeologist Mike Bishop in *Ancient Warfare* magazine.

The Hadrianic Fort at Ravenglass

THREE VIEWS OF THE HADRIANIC fort and naval base at Ravenglass, Cumbria, famous today for the remains of its bath house. The site of Ravenglass is a safe natural harbour, formed at the confluence of the Rivers Mite, Irt and Esk. A small earth and timber fortlet was built on the site around the time Hadrian's Wall was constructed in the 120s, this possibly part of a western defensive system ranging down the Cumbrian coast, designed to prevent the newly fortified northern frontier being bypassed by maritime raiders.

Around 130 this fortlet was demolished to enable a full stone-built auxiliary fort to be constructed there called Glannaventa. This larger structure occupied a flat plain 10m above the high water mark of the three rivers and is that illustrated by Graham here. It was typical of forts of this period with its central *principia* headquarters building and *praetorium* commanding officer's quarters in the centre, these surrounded by barracks, small *fabricae* workshops and granaries. Like all Roman forts it featured four gateways, one centrally set in each wall, though the principal one was that to the east through which the road to the forts at Ambleside (tentatively identified as Roman Galava) and Hardknott (Roman Mediobogdum) ran. This mid-Hadrianic fort also featured a large ditch, partly created using a natural gully.

The first defences on its seaward side have since been lost to coastal erosion, though archaeological excavations have found the large *vicus* civilian settlement which was established to its north. Many isolated forts in Wales have evidence of practice camps and small earthworks in close proximity that have not survived elsewhere. Graham has therefore included one such work here next to the fort.

Meanwhile, the fort's naval importance is indicated by the military unit based there. From the mid-second century, this was the *cohors Primae Aelia Classica* of the *Classis Britannica*.

Graham's three images of the fort in the 130s feature two panoramic views and one of activity in the civilian settlement (overleaf). The first reconstruction was painted for 'The Romans in Ravenglass' community project, and was based on evidence discovered in the then recent excavations undertaken by Kurt Hunter-Mann and his team from York Archaeological Trust. A further reconstruction showing the site looking south (above) was then painted for use on an interpretation panel installed near the remains of the Roman bath house (shown left foreground). It is reproduced here with permission of the Lake District National Park.

Activity in the Ravenglass Civilian Settlement

The final image Graham painted for the interpretation panel at Ravenglass is of a blacksmith hard at work in the *vicus*, reproduced by courtesy of The Lake District National Park.

Fort Gateway at Moresby

THE EAST GATE AT THE Roman fort at Moresby (Roman Gabrosentum), Cumbria. Graham's reconstruction was part of a series for use on interpretation panels at the site, installed in 2002 by Cumbria County Council. Moresby was another Hadrianic fort and naval base which was also part of the Cumbrian coast chain, including Ravenglass as detailed above.

The *Vallum* Crossing at Benwell Fort on Hadrian's Wall

Benwell Fort (Roman Condercum) is one of the most important and best known sites on Hadrian's Wall, located at its far eastern end and today on the outskirts of Newcastle. It was the second of twelve forts constructed along the length of the wall, and was built on a strategic, naturally level hilltop 127m above sea level which gave the site its contemporary name, this translating as 'a place with a wide view'. Though little is left of the fort today, since the northerly portion was destroyed in the early 1860s to construct a reservoir, and the rest in the 1930s to make way for a housing estate, rescue excavations did show it to be typical of other forts along the wall. All that remains of the fort and its *vicus* today are the monumentalised crossing of its vallum defensive ditch and a small temple in the civilian settlement. Graham's initial painting of the crossing was used in an interpretation panel by Hadrian's Wall Trust, though he felt it was not dramatic enough. Inspired by moody scenes from Anthony Mann's 1964 epic movie *The Fall of the Roman Empire*, Graham later repainted the image to make it more melancholic and reflective.

The Northern Frontier

Here Graham has painted one of the better known towers on Hadrian's Wall, Turret 44b at Mucklebank, for an interpretation panel displayed by the Hadrian's Wall Trust. His artwork followed the advice of archaeologist Mike Bishop who suggested to Graham that there should be a conspicous difference in the landscape north of the wall compared to the south. Here, at left, on the Roman side one can see managed woodland including hazel trees which provided a valuable source of wood for spear shafts. At right, north of the border the landscape is less productive. Reproduced by courtesy of Hadrian's Wall Trust.

The Cavalry Charge

Here Graham brilliantly brings to life the fierce charge of an *ala* of Roman auxiliary *equites*, this being set in what is now northern England during the early years of Trajan's reign as the northern frontier in Britain gradually settled back to the line of the Solway Firth–Tyne.

Graham has based much of the fine detail in this evocative drawing on archaeological finds from Britain. For example the Weiler-type helmets are based on examples from sites such as Northwich, Ely, Ribchester and Hallaton, as well as continental finds from the Lower Rhine and Xanten. Additionally, we can see the Ribchester-style masked helmet worn by the *signifer* whose wider panoply (including his *signum* standard) is based on the tombstone of Oclatius, a standard bearer who served with the *ala Afrorum*. This was found at Neuss in Germany.

Meanwhile, the various horse-harness fittings visible are based on common archaeological finds found across the northern *limes* in Britain and Germany, with the addition of the very large fitting on the horse at left which is based on an example from Cirencester.

(illustration overleaf)

VEX · ALA
GALLORVM
PETRIANA
C R

ALA PETRIANA

The Wigan Bath House

Excavations in Wigan (Roman Coccium), Lancashire, prior to the development of a new shopping centre, discovered the remains of a bath house which featured as part of the Roman fort there. The fort was built with ditch, bank and timber palisade around AD 70, staying in use until the 160s when it was demolished along with its bath house.

Graham's painting was used on an interpretation panel next to the remains of the bath house which was put on display after the excavation. Here we have a scene inside the *caldarium* hot room with bathers in the background using their strigils to clean off sweat and oil.

Roman Warriors

Mauretanian *Symmachiarii* Light Horse

NUMIDIAN AND MAURETANIAN *Symmachiarii* light horse provided expert javelin-armed skirmishers in the armies of the earlier phases of the Principate, and were the template for later Roman light cavalry specialists including *equites Illyriciani*.

Trajan's Column provides our best source for the appearance of these elite North African horsemen, originally from Numidia after Rome's early engagements there and later from neighbouring Mauretania. In the Second Punic War against Carthage the defection of the Numidians to the Romans was instrumental in their triumph over Hannibal. As can be seen in his loving artwork, Graham is a particular fan. He says:

> Just as nineteenth-century Americans described the Plains Indians as 'the finest light cavalry in the world', one can easily imagine the Romans giving that sobriquet to the Numidians and Mauretanians.

One prominent Mauretanian was Lusius Quietus, a member of the royal family whose father had obtained Roman citizenship. Quietus too earned equestrian status as an officer in the Roman cavalry under Domitian and later fought with distinction in the Dacian, Parthian and Jewish wars of the Emperor Trajan, becoming a senator in the process. He was made governor of Judaea and ruthlessly put down the Second 'Kitos War' Jewish Revolt after Trajan's death. His popularity within the army was undoubtedly seen as a threat by Trajan's successor Hadrian, who is suspected of having Quietus murdered soon after he came to power.

The Mauretanian cavalryman shown here wears a simple tunic and rides bareback without reins, holding a round shield faced with leather. Although much of the equipment the figure carries on Trajan's Column is now lost, he would almost certainly have been armed with several light javelins.

In service such cavalry were mainly used for scouting and skirmishing. They were particularly noted for fighting in a formation called the Cantabrian Circle. Here, a group of horsemen formed a single-file rotating circle, each man throwing his javelins at the closest point to the enemy battle line. The effect was a continual stream of javelins hitting the enemy formation in close proximity to each other, thus providing a very dense concentration of firepower.

CHAPTER 5
THE HIGH POINT OF EMPIRE: THE ANTONINE AND SEVERAN DYNASTIES

'Friends, comforts, family – if they interfere with your peace to work you cut them off.
And you spend the rest of your life wondering if it was worthwhile.'
PAUL GAUGUIN, *LUST FOR LIFE*, 1956.

THE LEGIONARY LEGATE

A *LEGATUS LEGIONIS* in senatorial toga performing a *souvetaurilia* libation sacrifice on an altar. His tunic features two vertical *clavi*, and as an additional mark of his status he wears red senatorial boots. This figure is based on a scene from the Bridgeness Roman distance slab that dates to around 142. As mentioned earlier, it was erected to mark the completion of a section of the Antonine Wall built by a vexillation from the Caerleon-based *legio* II *Augusta* (whose *vexilla* standard can be seen in the image).

If the image on the slab shows the legion's senior legate, then at that date he would be Aulus Julius Tiberius Claudius Charax from Pergamon in western Anatolia. He was better known in antiquity as a priest, philosopher and historian. With no previous military experience he was nevertheless given command of the south Wales-based legion between 141 and 144, almost certainly because he was a close friend of the Emperor Antoninus Pius, and earlier Hadrian, who had raised him to senatorial status. The altar depicted by Graham is one to fortune and is based on a find from Castlecary Roman fort on the Antonine Wall in modern North Lanarkshire which appears to show a genuine historical spelling mistake in that the first two abbreviated letters on the bottom line should read P.F., meaning PIAE FIDELIS, and not P.S. as depicted on the original. This painting appeared in Graham's first book for Osprey Publishing which was entitled *Roman Military Clothing 1*, and is published with their kind permission.

The High Point of Empire: The Antonine and Severan Dynasties

FORTVNAE
VEXILLA
TIONES
LEG. II AVG.
LEG. VI VIC.
P.S.P.L.L.

The High Point of Empire: The Antonine and Severan Dynasties

The Bridgeness Cavalryman

This figure painted by Graham is a reconstruction of a mid-to-late Principate *eques*, based on a sculptural image also shown on the Bridgeness slab.

The monument depicts a typical trope of the time showing a Roman mounted trooper riding down a naked native barbarian in the far north of Roman occupied Britain. The cavalryman shown on the slab is easily recognisable by the type of equipment he is equipped with. This includes a short *lorica hamata* mail shirt over a *subarmalis* padded jacket, with leather *pteruges* strips attached to protect his thighs and groin. His bronze helmet is of the 'Guisborough' type, this named after an example found in the North Yorkshire market town in 1864. Graham has based this particular specimen on one found in Worthing, Norfolk, which had a vizored mask and most likely originated in the Danubian region. Its ornate decoration featured an eagle's head whose beak formed the helmet crest, with sea dragons depicted on either side with curling bodies and whipping three-pronged tails. Such decorated helmets belong to the broader 'pseudo-Attic' group, with a lively scholarly debate continuing over whether they were purely sports and parade helmets, or were also used in battle. Graham's image was originally painted to accompany an article in *Ancient Warfare* magazine by Professor David Breeze.

Antonine *Eques Dromedarius* on Desert Patrol

One of Graham's earliest military reconstructions, this picture was painted for *Military Illustrated* magazine in 1995. It shows another *eques dromedarius* out on patrol, with this eastern trooper much better equipped than the earlier depiction. He wears a simple bronze helmet based on an example found in the Sava river near modern Brod in Bosnia and Herzegovina. By this later Principate date, it would have been considered something of an antique, perhaps suitable for a member of a mixed unit of auxiliary mounted troops and foot in a remote desert post. He also wears a short *lorica squamata* scale-mail hauberk and carries a buckler-type shield, while his offensive weaponry includes spear, bow and a quiver of javelins. Graham's image has inspired a number of model and wargaming figures and kits, most notably a 54mm *eques dromedarius* by Verlinden Models.

The High Point of Empire: The Antonine and Severan Dynasties

ROMAN WARRIORS

The High Point of Empire: The Antonine and Severan Dynasties

Avitus, a Roman *Optio* from Chester

Here Graham has illustrated another real-life individual, this time Caecilius Avitus who was an *optio* of *legio* XX *Valeria Victrix*. *Optiones* were executive officers in a Roman century of legionaries (as in this case) or auxiliaries, most commonly (as an *optio centuriae*) acting as the second-in-command to the unit's centurion. In battle these were stationed at the rear of a given column to ensure its cohesion while the centurion led from the front.

We know of Avitus through his tombstone, this being one of a number found in Chester commemorating soldiers of the legion. It is now displayed in the Grosvenor Museum there, with its detailed inscription (RIB 492) translating as 'To the spirits of the departed, Caecilius Avitus of Emerita Augusta, an *optio* of the Twentieth Legion Valeria Victrix, served fifteen years and lived for thirty-four years. His heir had this stone made.' Avitus is one of three legionaries in Chester we know who came from Emerita Augusta, the modern city of Mérida in Spain. This was originally founded as a *colonia* by Augustus after his Cantabrian Wars.

Avitus' memorial was found reused as building stone in the remains of the north wall of the legionary fortress in 1891 and measures 0.5m wide by 1.25m tall. His image is very clear, showing the *optio* in his casual clothing rather than full military dress. The bearded soldier holds a tall knob-headed staff in his right hand, while in his left he holds the handle of a square wax writing tablet case. This was the inspiration for Graham to show Avitus actually writing notes while carrying out his duties in his illustration. Meanwhile, over his *tunica* he wears a *sagum* heavy cloak with its ends crossing over to hang down his front as two tails. Avitus' *gladius hispaniensis* hangs from his right hip and features an over-large pommel.

The *optio*'s memorial is undated, but based on the features on his tombstone image Graham has estimated this was set up before 200. Given such a date, the heir who set the stone in place would most likely have been a fellow soldier rather than a family member.

Antonine Naval Officers

As the Principate progressed the regional fleets continued to play a key role in maintaining the maritime frontiers of the empire, whether on the open ocean, in littoral coastal regions or along river systems. In particular, at this time they had a major part to play in the Marcomannic Wars when the future Emperor Publius Helvius Pertinax was at one stage a *navarchus* squadron commander in the *Classis Flavia Moesica* lower Danubian fleet in Moesia Superior and Inferior, and later the *praefectus classis* admiral in charge of the *Classis Germanica* on the River Rhine.

Here Graham has illustrated three naval officers of the period; they originally appeared in Osprey Publishing's *Imperial Roman Naval Forces 31 BC – AD 500* and are reproduced here with their kind permission. The central figure is a tribune shown in his imperial finery, wearing a rigid leather *corium* corselet over a *subarmalis* which comprises multiple layers of linen. Atop his hauberk he wears multiple high-quality silver *phalerae*, these showing his seniority. Meanwhile the *subarmalis* is decorated with fringed *pteruges* at the shoulder and waist, while he also wears an expensive *cingulum* dagger belt decorated with openwork squared plates. Graham's inspiration for the details here were archaeological finds from Roman Viminacium, the provincial capital of Moesia Superior in modern Serbia. The belt also features *belteola* strap-end leaf-shaped and half-moon decorations. The tribune wears *cothurni venatici* laceless closed boots, these again based on finds from Didymoi in Egypt. He is portrayed here as an officer of one of the two Danubian fleets, the other being the upper-river *Classis Flavia Pannonica*. The original research for this fine image was carried out by Raffaele D'Amato.

Meanwhile, at left is a reconstruction of the mid-second century centurion M. Herennius Valens, based on his grave stele from Vinkovci (Roman Colonia Aurelia Cibalae) in modern Croatia. This was later the birthplace of the Dominate emperors Valentinian and Valens. The centurion died at the age of seventy-five, having served in one of the Danubian fleets for an impressive fifty years. Notably, on his memorial depiction he wears no waist belt, this usually regarded as a symbol of status and military rank. This may indicate long-service as a *beneficiarii* on the staff of a provincial governor or procurator. He is depicted on the stele wearing a simple woollen cloak over a broad *dalmatica* tunic featuring wide sleeves.

The last figure at right is a reconstruction of Q. Statius Rufinus, a marine of the classis Misenensis Tyrrhenian fleet whose grave stele was found in Athens. His name translates as 'the short red one', which Graham thinks might be a pun on his red hair. He carries a small bundle of wax tablets within a decorated box called a *codex ansatus*, and a dagger attached to a *zona militaris* knotted sash rather than a leather belt.

The High Point of Empire: The Antonine and Severan Dynasties

123

The High Point of Empire: The Antonine and Severan Dynasties

Antonine Auxiliary Archer

A WESTERN AUXILIARY ARCHER OF the time of the Marcomannic Wars when Rome struggled to hold the Danubian frontier against waves of opportunistic Marcomanni, Quadi and Iazyges. Here Graham has illustrated this well-armed warrior in a short *lorica hamata* hauberk, with his belt plates and decorated openwork dagger scabbard based on finds from Regensburg (Roman Castra Regina) in eastern Bavaria that date to the mid-to-late second century. The remains of a similar scabbard were also found at Dura Europos dating to the mid-third century, showing the design's ubiquity and long-standing use.

Meanwhile, his helmet is of an older design which illustrates the length of time personal equipment remained in use among military personnel, though his *spatha* long sword and its fittings are far more up to date for the time. Swords were now increasingly worn on the soldier's left side, attached to a baldric rather than a waist belt. This figure was painted for the *muli mariani* exhibition when it was first shown at Regensburg Museum, eastern Bavaria in 2016 (prior to the exhibition moving to Kalkriese Museum in 2019 as noted above), hence the inclusion of local archaeological finds, with the details supplied by Dr Christian Koepfer.

A Legionary of the Marcomannic Wars

As the Principate progressed through the second century the traditional legionary panoply, well illustrated in Graham's earlier plates, was beginning to change. This was largely a response to the much wider variation in the nature of the opponents they were now facing. Previously, the legions had most often faced a similar infantry-heavy force (excepting the Parthians in the east), but were now tackling a multitude of threats, many of a differing nature that required a more flexible response. In particular, the heavily armoured charging lancers of the Sarmatian Iazyges faced by the Romans in the Marcomannic Wars made a strong impression.

This change is shown in real time on four of the monuments set up in Rome by four great warrior emperors – Trajan's Column, the Column of Marcus Aurelius and the Arches of Septimius Severus and Constantine. The last is particularly important given it is in effect a time machine, built in 315 in the Dominate phase of empire to celebrate Constantine's victory over Maxentius at the Battle of the Milvian Bridge in 312. At the time the imperial *fiscus* was running low, as it had been used by Maxentius to fund his failed defence of Rome. Therefore, the architects of the new arch sourced panels from existing monuments to complement its new and contemporary depictions of his martial success. These included the four panels from the Great Trajanic Frieze which comprised slabs from a monument built to celebrate victory in Trajan's two Dacian campaigns, and similar panels from a lost Arch of Marcus Aurelius made to celebrate his successes in the Marcomannic Wars.

The change in the equipment of the later Principate legionary was initially evident in his weaponry. First, from the reign of Septimius Severus the longer cavalry-style *spatha* sword began to replace the shorter *gladius* for all Roman foot soldiers (as seen with the auxiliary

The High Point of Empire: The Antonine and Severan Dynasties

archer just described). This weapon was up to 80cm in length, although some of one metre-length have been identified. In legionary use, the new sword was suspended from a baldric on a Sarmatian-type scabbard slide, and came to dominate Roman military equipment in the west until the Empire's end there, continuing in use in the east afterwards. It seems likely the adoption of this weapon had its origins in the need for more reach to tackle mounted armoured opponents.

A similar change is also evident in the use of the *pila*, they being gradually replaced by a *hasta* thrusting spear of between 2 and 2.7m in length in the same time period, or by the lighter auxiliary *lancea* short spear which could also be thrown. This change is visible actually taking place on the four monuments detailed above. Thus on Trajan's Column, the Column of Marcus Aurelius and the reused panels on the Arch of Constantine the legionaries are shown in classic *lorica segmentata* armour and are mostly armed with *pila*, while on the Arch of Septimius Severus and on the contemporary panels of the Arch of Constantine these have been replaced by long and short spears. The former were again a response to the experience of fighting mounted opponents more frequently, as with the longer sword. A legionary spear wall made much more sense when engaging such opponents than the use of impact weapons like *pila*; one such legionary phalanx is actually depicted on a panel on the Arch of Septimius Severus, there countering Parthian cataphracts.

Moving to the defensive panoply, this change is also evident with the shield. In the later second century the traditional *scutum* began to be replaced by a large flat (sometimes slightly dished) oval body shield, confusingly still called a *scutum*. This new design was of simple plank construction, with stitched-on rawhide, and was strengthened with iron bars. The two types appear to have been used side by side for some time, with examples of both found at the fortified frontier-trading town of Dura Europos in Syria dating to 256. This transition is also very evident on the four monuments detailed above, with many of the large round shields featuring on the Severan arch, and even more on the contemporary panels on the Arch of Constantine. Once again this change seems to have been associated with the type of opponent more commonly faced by the Romans, the round shield perhaps being more suited to dealing with a mounted threat. It certainly gave greater freedom of movement for the new swords and *hastae* coming into use with their greater reach, and would also have been cheaper to produce.

Not surprisingly, a change was also evident in the body armour of the legionary as the Principate approached its end. Thus on Trajan's Column and the Column of Marcus Aurelius most are wearing *lorica segmentata*, as they are on the reused panels on the Arch of Constantine. However, on the Arch of Septimius Severus there is a much higher proportion wearing *lorica hamata* and *lorica squamata*, this proportion increasing yet again on the contemporary panels of the Arch of Constantine. A key factor here was the cost of making, and particularly maintaining, *lorica segmentata* as the Principate navigated the economic tribulations of the 'Crisis of the Third Century'.

Meanwhile, as the Principate progressed, legionary helmets also became increasingly substantial, with the Italic 'Imperial' type disappearing entirely by the early third century. The Gallic 'Imperial' style did continue in use, but was increasingly supplemented by heavier, single-bowl designs reinforced by cross-pieces and fitted with deep napes, leaving only a minimal T-shaped face opening. These helmets provided exceptional levels of protection.

Graham has painted a legionary here at the cutting edge of this process of change as Rome struggled to halt the Germanic and Sarmatian incursions in the 170s and 180s across the Danubian *limes*. The illustration was created in consultation with German re-enactor and archaeologist Dr Boris Burandt, and is largely based on some of his line drawings. It also pays homage to Graham's favourite movie, *The Fall of the Roman Empire*. The helmet is based on a well-preserved example from Heddernheim (a city district of today's Frankfurt am Main, then Roman Nida) in Germany. For many years this was classed as a cavalry helmet, but recent research (most notably by Dr Thomas Fischer) has now shown it to be a late Principate legionary helmet. When the research was published Graham found it particularly noteworthy as in the movie infantry troops are shown wearing exactly this type of helmet, an affectation dismissed at the time as unhistorical. The soldiers in the film also wear long-sleeved tunics under short-sleeved ones which is something seen on Antonine period sculptures, and yet another detail the film makers got correct argues Graham. His figure wears *lorica squamata* scale mail, this the most popular type of armour worn by legionaries on the column of Marcus Aurelius. There are also other contemporary innovations visible in Graham's fine illustration, including the ring-pommeled sword, broadsword baldric and the oval shield. Note also the *hasta*, here held in the guard position.

MILITARY MEN OF THE FAYUM PORTRAITS

THE FAYUM 'MUMMY' PORTRAITS from Roman Egypt are a type of highly naturalistic portraiture painted on wooden face boards attached to aristocratic embalmed burials, these often providing an astonishing re-creation of the individual when alive. They belong to the long tradition of panel painting, a very highly regarded art form in the Roman world. Such 'mummy' portraits have been found across Egypt, but are most commonly found around the basin of the Faiyum Oasis located in the desert immediately west of the Nile south of modern Cairo. They are particularly associated with the archaeological sites at Hawara, and the Hadrianic Roman city of Antinopolis. Here over 900 have now been recovered in the various necropolises there. Due to the hot dry Egyptian climate, most of the paintings are very well preserved and often retain brilliant colours largely un-faded by time. They are now known after the Fayum (or Faiyum) region where they were found, though they were originally and incorrectly styled as Coptic portraits.

While painted cartonnage 'mummy' masks made of layers of linen covered in plaster date back to Pharaonic times, the Fayum portraits were a specific innovation of Roman Aeygyptus, the province there from the later Republican period. It is currently unclear when their use ended, though recent research suggests this occurred in the mid-third century.

The striking painted portraits covered the faces of the deceased after they had been mummified for burial, with the wooden panel mounted within the bands of cloth that were used to wrap the bodies. Most of the Fayum portraits have now been detached from their embalmed burials. They show the head, and often upper chest, of the deceased as viewed from the front. Given the level of detail, they are in effect a snapshot of the dead individual, usually when in the prime of life.

THE HIGH POINT OF EMPIRE: THE ANTONINE AND SEVERAN DYNASTIES

In these detailed images of specific individuals buried with panel portraits in the Fayum region, Graham has matched them with the various items of clothing indicated by the portraiture and other archaeological evidence. In particular, the decoration around the neck and the gamma motifs on the shoulders suggest all those shown were military men, given that civilian males were generally represented in the portraits wearing completely plain white clothes. Any suggestion of rank is purely hypothetical, and is based on the notion that the more decoration an individual had, and the more expensive the dye used on the clothing, the higher the pay. It is not clear, based on available evidence, if these individuals belonged to legionary or auxiliary formations.

The first painting (page 128) shows four men in yellow ochre cloaks, with the two at the rear based on portraits in the National Bibliotheque in Vienna (at left) and Würzburg University, Martin von Wagner Museum (at right). In the foreground, the individual to the left is based on a portrait in Milwaukee Public Museum, while that on the extreme right is based on a portrait in the Stockholm Nationalmuseum.

Meanwhile the next image (above) shows three officers in pink cloaks based on, from the left, a portrait from Vienna, a portrait in the Greco-Roman Museum

in Alexandria and a portrait in Munich. The man at left carries a spear of the type used by the *tesserarius* junior officers in Roman forts and camps who kept the watchword of the day. Meanwhile, the man on the right carries another type of spear with a broad blade usually associated with *beneficarii* seconded for special duties (such spears are described in full later).

The next illustration (left) also features an officer in a pink cloak, this based on a portrait in Vienna.

Graham's penultimate Fayum panel portrait (below) shows three men wearing red cloaks. The two at centre and right are based, in the first instance, on a portrait now in Yale University's Art Gallery, and secondly on one in the Egyptian Museum of Antiquities in Cairo. Meanwhile the man at left is based on a young

The High Point of Empire: The Antonine and Severan Dynasties

man in the famous Tondo portrait of two brothers, also in the Egyptian museum Cairo. He is shown here in Graham's illustration as the younger, least-experienced of the three, though is perhaps senior in rank to the other two men in this particular image given his staff of office. This reflects how patronage could have an impact on promotion in the Roman army.

The final image (above) shows four men in different coloured cloaks. The first at left shows an officer in a blue-purple *sagum* and is based on a portrait in the Boston Museum of Fine Arts, while the second wears a bright blue cloak and is based on a portrait in Melbourne's National Gallery of Victoria. Meanwhile the figure in the purple cloak uses a portrait in Hildesheim's Roemer-Pelizaeus Museum as its inspiration. This portrait appears to show a gilded brooch with a hanging chain very similar to a recently discovered example from Vindolanda in England. The last figure at the far right in the red cloak is based on a portrait sold recently at auction in America.

The Regensburg Cavalryman

An Antonine auxiliary heavy cavalryman on the northern frontier at the time of the Marcomannic Wars, most likely from an early unit of *equites contariorum* lancers.

These were an innovation in Roman service based on contact with the Sarmatians along the Danubian frontier, particularly during this conflict when they were allied at various times with the Germanic Marcomanni and Quadi. He is armed with a 3.5m long *contos* (note the Latin spelling) lance and wears a fine *lorica squamata* equestrian hauberk, together with elaborate greaves decorated with mythological imagery. The helmet is based on a find from Theilenhofen in Germany, and is another example of the 'pseudo-Attic' type. Graham says that if you think the helmet looks familiar, that is probably because it was the inspiration for the black helmets worn by the Praetorian Guardsmen in the movie *Gladiator*. This image also first appeared in the *muli mariani* exhibition at Regensburg Museum in 2016.

The High Point of Empire: The Antonine and Severan Dynasties

133

Roman Warriors

The High Point of Empire: The Antonine and Severan Dynasties

The Price of Failure

CLODIUS ALBINUS WAS THE GOVERNOR of the province of Britannia when Septimius Severus acceded to the throne in 193. Severus rightly identified the experienced soldier as a potential future rival, and initially made him his *caesar* in the west to keep him dynastically close while the new emperor campaigned in the east. However, when Albinus heard that Severus had also appointed his sons Caracalla and Geta *caesar* too he saw the writing on the wall and usurped, leading the three British legions and other western troops to catastrophic defeat at the titanic Battle of Lugdunum (modern Lyon, capital of Gallia Lugdunensis) in February 197. This finally cemented Severus in power, securing the dynasty's future until the assassination of Alexander Severus by Maximinus Thrax in 235.

The failure of a usurpation always resulted in a predictable outcome, especially one which came so close to success as did that of Albinus. Thus, not only was he beheaded (possibly post-mortem), but Severus then ritually trampled over his headless corpse on his charger to show the Roman world that imperial order had been restored. Similarly, his loyal legionaries found their own ways to show their continued devotion to the victorious commander, for example declaring him *imperator*.

This need to show loyalty to Severus was even more important for the defeated survivors of Albinus' army: they faced a stark choice between declaring for the newly secure emperor or execution. One overt way of showing their renewed loyalty to the Severan regime was to deface their legion's existing *imagio* standard which featured a life-like image of the emperor, or in their case the usurper Albinus. This standard was second only to the *aquila* standard in terms of importance within the legion, and its defacement was a traditional fate after a catastrophic defeat.

Here Graham has caught this act of deliberate imperial vandalism as it actually takes place, his beautifully animated artwork modelled on a real life *imaginifer*. This is Aurelius Diogenes, the *imaginifer* of *legio* XX *Valeria Victrix* at the end of the second century, whose gravestone was found in 1887 reused in the northern wall of the legionary fortress at Chester (RIB 521). The monument itself was either defaced in real life, or damaged when reused, given that it is now headless. Similarly, the image of the emperor atop Diogenes' standard is also badly disfigured. Some have argued this shows the monument was never actually finished, with its dedication only partially complete, though the damage does appears to be deliberate.

On the tombstone Diogenes is shown unarmoured, wearing a *paenula* hooded cloak which Graham has depicted with its characteristic W-shape formed by the two side tails of the garment, this here dyed imperial purple. His *imagio* standard features the image of Albinus mounted on a stout shaft, with a carrying handle towards the base showing that when in use it was held high aloft for all to see, whether friend or foe. In Graham's portrait Diogenes attacks Albinus' bust atop the standard with his *pugio* legionary dagger.

Interestingly, Diogenes' tombstone is only one of two known funerary monuments memorialising such individuals, though a number are also represented in other ways, for example in non-funerary sculpture. The other tombstone is that of the Claudian-period Genialis Clusio, *imaginifer* of the auxiliary *cohors* VII *Raetorum*. It is noteworthy that here we have something very rare, an *imagio* attached to an auxiliary unit, perhaps reflecting imperial favour after loyal service to the sitting emperor.

Severan Legionaries in the East 1

WHEN SEPTIMIUS SEVERUS BECAME EMPEROR in 193 as last man standing in the 'Year of the Five Emperors', his first priority was to deal with his remaining rivals, Pescennius Niger in Syria and (as described above) Clodius Albinus in Britain. The former had already been proclaimed emperor in Antioch-on-the-Orontes by the eastern legions around the time of Severus' own elevation, and so was his first target. As he set out, Severus first secured his western flank by proclaiming Albinus his *caesar*, and then promptly headed east where he fought a year-long campaign against Niger, finally defeating him at the Battle of Issus in May 194. Here he captured his opponent as he attempted to flee to Parthia where, in desperation, Niger hoped to take refuge with its ruler Vologeses V. Niger was beheaded soon after, with Severus then confiscating Niger's estates and wealth to boost his own family coffers. Then, having defeated one rival, Severus turned his attention to the Parthians in the first of his two eastern campaigns.

The pretext for this first campaign came in the form of the Roman vassal states Osrhoene, Adiabene and Hatra which had used the distraction of Severus' campaign against Niger to massacre the Roman garrisons in key border fortresses, then seizing them, and finally besieging the important trading city of Nisibis. They actually claimed allegiance to Severus (saying their targets had been the troops of Niger) but gave their game away by keeping the territory they had seized, clearly being encouraged to cause trouble by Parthia. Another factor here behind the Roman motivation to intervene in Mesopotamia was the huge military force that Severus had at his disposal, with his own loyal troops together with those of the defeated Niger. Such a force needed suitable employment to avoid discontent, added to which the ambitious Severus was also keen to test himself against the reputation of the likes of Trajan.

War was duly declared and Severus led his first expedition into Mesopotamia, aiming to crack down on the recalcitrant vassal states but also with his eye on glory against Parthia. Unsurprisingly, the campaign was successful given the size of force he deployed (a lesson not lost on him in his later campaigns including his *expeditio felicissima Brittannica* to Britain, see below) and the vassals were all brought to heel. Here, Osrhoene surrendered straight away, Adiabene was captured and Hatra conceded (though was not captured), with the siege of Nisibis broken. However, his plans to use this platform to continue the campaign into Parthia proper were curtailed when news reached him of his next great challenge, the usurpation of Albinus in Britain. Severus therefore rapidly returned to the west with most of his veteran troops and was finally victorious in February 197, as set out above.

Severus then turned back to the east and Parthia, aiming to make his name as a great conquering emperor. Once back in theatre there he immediately assaulted the Parthians, with the war a great success. It lasted from late 197 through to the end of 198, by which time the Parthian capital at Ctesiphon had been sacked by his legions and the northern half of Mesopotamia annexed into the empire. This was a punishment of the former vassal states for their earlier opportunistic land grab after he'd defeated Niger. The only negative aspect of the campaign was his failure to capture the fortress of Hatra again, though he did expand the limes Arabicus border defences on the eastern frontier and in the process constructed major new fortifications in the Arabian Desert at Basie (Roman Basienis) and Dumata.

THE HIGH POINT OF EMPIRE: THE ANTONINE AND SEVERAN DYNASTIES

The campaign over, instead of heading back to Rome Severus decided to tour his eastern provinces, a process which lasted four more years. This may have been a deliberate nod to Hadrian, Severus never missing an opportunity to measure himself publicly against any of his illustrious forebears. In terms of his route, this took him through Egypt (where he viewed the body of Alexander the Great, the Pyramids and the recently repaired Sphinx) and Cyrenaica. Severus then returned to Rome in the summer of 202 where he celebrated his *decennalia* with a victory games and oversaw the marriage of his elder son Caracalla to Fulvia Plautilla, daughter of Gaius Fulvius Plautianus, the Praetorian Prefect and fellow Lepcis Magnan.

Severus' campaigns are notable for his recruitment of three new legions in the east, these being I *Parthica*,

II *Parthica* and III *Parthica*. The second became his own personal legion, in much the same way as *legio* X *Equestris* had been Caesar's own. Indeed, to differentiate it from all of the other legions across the empire, its first cohort was expanded to include six centuries of 160 men rather than the usual five. Further, once back in Rome, Severus based the legion at Albanum 34km from the capital to keep an eye on the elite classes there. Prior to this, all Roman legions had been based at legionary fortresses around the borders of the empire, his move thus a major break with tradition. Equally important here is the fact that, with his three new legions, the total complement of established legions in the empire rose to its Principate height of thirty-three.

We can obtain great insight into the equipment and armament of the legionaries Severus led in his two eastern campaigns from the reliefs on the Arch of Septimius Severus at the head of the Forum Romanum in Rome. This was built at the beginning of the third century to celebrate his victories in the east, and was originally topped with a gilded four-horse chariot featuring the emperor with his two sons. In particular, the arch features four large relief panels showing highly detailed military imagery:

- Relief 1 on the left Forum-facing panel shows preparations for the first of the two campaigns, a battle scene featuring a large number of troops, and the liberation of the besieged city of Nisibis at the end of the first campaign, with the enemy leader there fleeing to the right.

- Relief 2 on the right Forum-facing panel is sadly damaged and is thought to have shown the revolt of a Roman ally, perhaps Osrhoene. In the upper register, we see how Severus later announces the annexation of Osrhoene and Nisibis.

- Relief 3 on the left Capitoline Hill-facing panel is better preserved and shows the second campaign, specifically against Parthia at the end of the second century. Here we see the Roman attack on Seleucia-on-Tigris, with Parthian troops fleeing left and right. The upper part also shows the citizens of the town surrendering.

- Relief 4 on the right Capitoline Hill-facing panel shows the last battle of the war, namely the siege and sack of Ctesiphon, the Parthian capital. A siege engine is shown being employed to breach the walls and the city then surrenders. In the upper register we see how Septimius Severus declares Caracalla as his co-ruler, with Geta named as the crown prince. This elevated the former as an *augustus*, the latter remaining a *caesar* for the moment.

Finally, other reliefs on the arch include images of Winged Victory flying in the spandrels, individual statues of the four seasons, and prisoners of war on the pedestals. Importantly for us we also see how the loot is being transported, these images including representations of the legionaries.

In his fine artwork (page 135) showing legionaries on campaign with Severus in the east Graham has based his interpretations on images from the arch. The most common legionary helmet shown there is the Attic type, with most examples fitted with hinged cheek guards and very low brow-bands. However, as these helmets are often regarded as conventional, an example based on an archaeological find from Bodegraven in the Netherlands has been used instead. This style is shown on the legionary at right, his helmet further decorated with a horsetail plume. Meanwhile the legionary on the left wears a helmet design of Ostrov type styled on the Phrygian cap, this based on warriors depicted on the arch flanking the imperial headquarters and therefore likely to show troopers from *legio* II *Parthica* given that Praetorian guards are shown elsewhere. Ironically some modern scholars deem the Ostrov type to be cavalry helmets, although infantrymen are more commonly shown in contemporary art wearing Phrygian style headgear.

Meanwhile, elsewhere in Graham's picture we can see the late Principate transition taking place in legionary equipment. For example, while the legionary at right wears *lorica segmentata* banded iron armour, his companion at left wears the *lorica hamata* mail now coming back into fashion. Meanwhile, while the warrior on the right carries the traditional rectangular *scutum*, his counterpart is carrying the oval plank design that had become more common from the time of the Marcomannic Wars. Finally, in terms of weaponry long gone here is the *gladius hispaniensis* sword, with both legionaries carrying the longer *spatha*. Further, there is not a single *pilum* in sight. Instead, the legionary on the left carries a *lancea*.

The High Point of Empire: The Antonine and Severan Dynasties

SEVERAN LEGIONARIES IN THE EAST 2

Here are two more Severan legionaries campaigning in the east, again showing the transition in equipment which began in the reign of the dynasty's founder. On the right, the legionary still carries a *pilum*, though is now wearing *lorica squamata* scale mail and has an oval plank body shield. However, this process of change is far more evident with his companion on the left since this warrior is an entirely new type of legionary, the *lanciarii* light trooper equipped with a quiver of javelins. Such troops, who operated like the *velites* of the earlier Polybian legions, skirmished forward to deter mounted bowmen and other lightly armed missile troops and were introduced as a counter to the eastern horse archers who proved such difficult opponents for the legionaries of the late Republic and Principate. They are first attested in gravestone epigraphy as serving in the ranks of *legio* II *Parthica* in the context of Caracalla and Macrinus' 215–218 Parthian campaign. Note the detail Graham shows on the rear of this soldier's round plank body shield, with the iron reinforcing bar visible which gave the relatively simple design such strength.

SEVERAN LEGIONARIES ON CAMPAIGN IN WALES

Two late Principate legionaries on campaign in central Wales during the reign of Septimius Severus, shown beside the standing stone near modern-day Barmouth. The troopers would have been based at the nearby Roman fort at Pennal, this later abandoned at the end of the third century.

The two legionaries again show the transition taking place in legionary equipment at this time. Both are kitted out with late-model Principate helmets giving very high levels of personal protection, *lorica hamata* hauberks and round plank body shields. However, though now equipped with *hasta* long thrusting spears rather than *pila*, these warriors still carry the *gladius hispaniensis*. Note the *sagum* hooded woollen bad-weather cloak, an essential item of equipment on the western and northern borders of the empire, especially in Britain.

The High Point of Empire: The Antonine and Severan Dynasties

VALERIUS MAXANTIUS, SEVERAN CATAPHRACT

As the Severan period progressed the mounted component in Roman armies continued to grow. In particular, in addition to the usual *equites*, shock cavalry armed with the long *contos* became a standard feature of Roman forces campaigning in both east and west. These were now formalised into full auxiliary *alae*, with the *equites contariorum* described earlier now joined by heavily armoured cataphracts called *equites cataphractarii*. The vector of transfer here in terms of equipment and tactics was largely from the east, with Roman cataphracts based on those they encountered in the armies of the Parthians. These frequently wore a suit of full-length scale armour called *lorica plumata* which covered the entire body, and a substantial helmet with gilded face plate. Their horses were also often similarly fully armoured.

Here Graham has painted a Severan-period lancer from a unit of early *equites cataphractarii*, based on the later funerary monument of Valerius Maxantius found in Worms (Roman Borbetomagus) in the modern Rhineland-Palatinate region of Germany. This dates to the late third century. His funerary inscription reads:

> To the divine *manes*! Valerius Maxantius, a horseman of the *numerus catafractariorum* [at this stage, *numerus* simply meant 'unit'], who lived thirty-two years and six months. His brother Valerius Dacus erected the tombstone.

The depiction of Valerius on the tombstone shows him in a fairly basic cataphract panoply, with his *contos* and a large round shield prominent. The shield was unusual for later period Roman cataphracts, but perhaps more common earlier. In Graham's interpretation, in addition to his long *lorica hamata* mail coat, Valerius wears a Heddernheim-type auxiliary helmet. This features a large brow guard, deep cheek pieces and a deep neck piece, together providing exceptional protection against missile fire.

A Late Severan *Aquilifer* in the East

As the Principate approached its end the *aquilifer* remained the senior standard bearer in the legions of Rome, carrying the *aquila* standard which still only left the legionary fortress or camp when the entire legion was deployed on active service.

Here we see an *aquilifer* of *legio* II *Parthica* carrying a particularly fine standard, this with the 'eagle' held in a crate-like gilded cage atop the standard's shaft. Graham's image is based on the tombstone of Felsonius Verus, an *aquilifer* who deployed from the legion's usual base at Albanum in Italy to Afamiyya in modern Syria (Roman Apamea) during Gordian III's two-year eastern campaign. This began in 243 and was the third time II Parthica had returned to the eastern frontier after earlier campaigns under Caracalla and Macrinus, and Alexander Severus. The dedication on Verus' memorial reads:

> To the spirits of the departed, Felsonius Verus, standard-bearer of the Second Parthian Legion, Gordian's forever loyal and faithful, in the century of the *primus pilus*, who served eleven years, born in Thuscia, lived thirty-one years, for whose memory his wife Flavia Magna set this up for her well-deserving husband.

Sadly for the Romans in the east, Verus' tombstone only survives because of its secondary use, after the rapid expansion of Sassanid Persian power.

This powerful empire, which represented the first true symmetrical military threat to the Romans, had been founded by its first king, Ardashir I, when, as the ruler of Parthian satrapy of Persis, he had usurped Artabanus V, the last Parthian king, in the 220s. Once in power Ardashir consolidated central control of his newly won territory, defeating a number of early local rebellions. Then, to win the political backing of the old Parthian aristocracy, he invaded the Roman east in 230, penetrating deep into Roman-controlled Mesopotamia and Syria. He then demanded the Romans give back all of their former Achaemenid Persian territories, including those in Anatolia. The Romans, caught off guard, tried to negotiate but this proved fruitless, so the Emperor Severus Alexander launched a campaign against the Persians in 232 (hence the deployment of *legio* II *Parthica* there at the time). Though the Romans were initially repulsed, the young emperor eventually succeeded in expelling the Persians. However, taking advantage of the chaos in Rome at the beginning of the 'Crisis of the Third Century' after the assassination of Severus Alexander in 235, Ardashir attacked again in 238. After his death, his son Shapur I then continued the war through to 240, capturing several cities in Mesopotamia and Syria, these including Carrhae and Nisibis.

After this conflict ended Shapur I turned his attention to the east, conquering Bactria and the western part of the Kushan kingdom. War then resumed in the west where he was defeated by the Romans under Gordian III at the Battle of Rhesaina in 243. The Roman emperor then campaigned down the Euphrates valley, but was finally defeated by Shapur I at Battle of Meshike in 244. Gordian III lost his life either in or after the battle and his successor Philip I the Arab signed a peace treaty with Shapur and withdrew. It may have been in these campaigns that Verus the *aquilifer* lost his life.

Unfortunately, peace was not to last in the east and in 253 the war resumed when Shapur I used a Roman intervention in Armenia as a reason to attack again. He conquered Armenia, killed its king, and then defeated a 60,000-strong Roman army at the Battle of Barbalissos. This left Syria open to a full Sassanid invasion in which he sacked Antioch-on-the-Orontes, the provincial capital. Also at this time the Persians captured the fortified frontier trading town of Dura Europos, and also Afamiyya. Here, they then set about a major rebuilding operation to bolster the city's stone-built defences, in expectation of a Roman counter-attack. This involved raiding the local cemeteries where they destroying the fine mausoleums and tombstones to repurpose the stone for use in the city walls. It is here the memorial to Verus was found, re-set to protect the Sassanid-controlled city against any future Roman aggression.

The High Point of Empire: The Antonine and Severan Dynasties

Roman Warriors

The High Point of Empire: The Antonine and Severan Dynasties

A Severan Centurion and his Wife from Chester

INFAMOUSLY, ONE OF AUGUSTUS' MOST noteworthy reforms of the military when he became the first emperor in 27 BC was to ban Roman legionaries and his newly created auxiliaries from getting married. This unhappy state of affairs was to last until the reign of Septimius Severus who, ever the champion of the military, realised the situation was becoming untenable. He therefore legalised marriage for his legionaries and auxiliaries, perhaps formalising what was already a reality in many parts of the empire. It also reflected Severus' strong relationship with his own wife Julia Domna. She often accompanied him on campaign and was known as the *mater castrorum* 'Mother of the Camps' among the soldiery.

Here we see this development in real time on the tombstone of Marcus Aurelius Nepos and his wife, found in 1887 in Chester (once more re-used in the north wall of the legionary fortress), where he had served with *legio* XX *Valeria Victrix*. Now on display in the Grosvenor Museum there, the cream-covered Manley sandstone slab is almost 2m in height and shows Nepos bareheaded with a neatly clipped beard, holding his centurion's staff in his right hand. In his left hand he holds a scroll, possibly his will. The dedication on the tombstone reads:

> To the spirits of the departed: Marcus Aurelius Nepos, centurion of the Twentieth Legion Valeria Victrix, lived fifty years; his most devoted wife had this set up.

The name of Nepos' wife, shown dimorphically much shorter on the tombstone imagery where she stands on a stone block (perhaps to emphasise Nepos' masculinity), is unknown: it was never added after her later death.

In Graham's image Nepos wears a *sagum*-style cloak, pinned on the right shoulder with a knee-type *fibula*. Meanwhile, his wife's hairstyle is based directly on the depiction on the tombstone which shows her wearing tight waves of neatly coiffured hair, this an early third-century style directly associated with Julia Domna, hence the dating of the commemorative slab.

Late Principate Cataphract

As detailed earlier, *EQUITES CATAPHRACTARII* had begun to appear in the early Severan period, and by the 230s were a common feature of Roman armies on campaign, particularly in the east.

Graham's wonderfully animated image here shows a western *cataphractarius* based on various tombstone stele, the well-equipped trooper belonging to the *ala firma cataphractaria* unit which served in the German campaigns of the then new Emperor Maximinus Thrax in 235 after his assassination of Severus Alexander. Much of the archaeological data used in Graham's reconstruction comes from the Rhine frontier, for example the Mainz-Heddernheim style helmet and the highly decorated greaves and thigh guards which feature images of Mars and a Medusa. The cheek pieces of the helmet are also influenced by examples found at Dura Europos.

Meanwhile, his mount's face-plate features an image of Hercules, while the horse's scale-mail coat is based on a trapper (or set of horse armour), one of several found at Dura Europos. This was made from copper alloy scales.

THE HIGH POINT OF EMPIRE: THE ANTONINE AND SEVERAN DYNASTIES

Roman Warriors

THE HIGH POINT OF EMPIRE: THE ANTONINE AND SEVERAN DYNASTIES

LATE SEVERAN LEGIONARY

HERE GRAHAM DEPICTS A LEGIONARY very different to those of a century earlier. While he retains the classic rectangular *scutum*, the rest of his equipment would sit easily with any trooper serving in the legions or *auxilia palatina* (see below) in the later Dominate phase of empire. Note his *hasta* spear, *spatha* long sword, *lorica hamata* hauberk with bronze pectoral fastening plates, and his high-quality bronze Niederbieder type helmet, this depiction based on fragments found in Lyon (Roman Lugdunum, capital of the province of Gallia Lugdunensis and site of Septimius Severus' earlier victory over Clodius Albinus). Graham has depicted this legionary with one other throwback to the earlier style of legionary equipment, his *cingulum militare* sword belt.

Severan *Beneficiarius* and Centurion

WHILE THE LEGIONS OF ROME are well known for their martial prowess and engineering skills, they are less well-known for another key role the legionaries and *auxilia* fulfilled. This was as *beneficiarii*, translating as troops assigned to special duties, most often as administrators to help run the various provinces of the empire.

In a given province the legal and military leadership function was provided by the governor, while the procurator acted as the finance minister who had responsibility for ensuring that the wealth from the province found its way into the emperor's *fiscus* treasury. However, one might note here how small the executive teams of the governor and procurator were, in total no more than sixty staff in a normal province. To give context, in Roman Britain this amounted to only 0.0017% of the estimated population of 3.5 million, compared to around 25% in public employ in Britain today. Clearly this was an insufficient number of officials to run the whole province, and therefore both the governor's and the procurator's teams were bolstered by the appointment of military personnel assigned from the provincial military establishment to assist with official duties.

Legionaries appointed to the governor's *officium consularis* administrative team were known as *beneficiarii consularis*, while those appointed to the procurator's staff were called *beneficiarii procuratoris*. A good example of an actual individual fulfilling one of these roles can be found in today's Museum of London, where the funerary monument of centurion Vivius Marcianus from *legio* II *Augusta* is displayed. Seconded from his legion's fortress at Caerleon in south-eastern Wales, this man served as a *beneficiarius* based at the Cripplegate vexillation fort in London in the early third century.

Here, at left, Graham has depicted a *beneficiarius* of just this period, the seconded legionary notably carrying a type of broad bladed *hasta* associated with the *beneficiarii* as a mark of office. This features wide shoulders on the spear blade with circular perforations either side, and an acorn-sized ball atop the spear tip to show its non-military function clearly. These were based on spears used for practice rather than in battle, known as *hasta praepilatae*. Small brooch-sized spearheads based on this design have also been found in association with *beneficiarii*, these perhaps used as badges of office.

Our *beneficiarius* is joined at right by a centurion of *legio* II *Parthica*, Graham's reconstruction being based on a statuette found in Rome and now in a private collection. His tunic decoration is based on actual textile finds.

THE HIGH POINT OF EMPIRE: THE ANTONINE AND SEVERAN DYNASTIES

Roman Warriors

THE HIGH POINT OF EMPIRE: THE ANTONINE AND SEVERAN DYNASTIES

LATE SEVERAN AUXILIARY OFFICERS IN THE EAST

GRAHAM'S IMAGE HERE IS BASED on a fresco found at Dura Europos showing members of the auxiliary unit *cohors* XX *Palmyrenorum* attending a sacrifice. At the head of the unit in the original image is its tribune Julius Terentius, the unit commander, here shown as the central figure in Graham's painting. He wears a white-fringed cloak over a white long-sleeved tunic decorated with short purple *clavi* stripes at the wrist and vertical extensions at the hem which terminate in notched bands. The man at right in Graham's image also wears a white cloak, again showing high rank, perhaps as a senior centurion. Everyone else in the original fresco image wears a yellow brown cloak, as with the *vexiliarius* standard bearer here.

The tunic decorations in Graham's image are based on actual textile finds from Dura Europos itself which show small details not visible in the ancient painting, for example the arrow-shaped terminals. All the belt fittings and brooches are also based on finds from the city. Although it obviously had no political meaning in Roman times the 'swastika' symbol, known to the Romans as the *crux gammata*, appears in Roman artefacts of various kinds. It occurs facing in either direction and may have been a sun symbol, a good luck token, or some sort of badge of rank, among other suggestions.

The *vexillum* is based on an example found in Egypt which is now displayed in the Museum of Fine Arts in Moscow. It shows an image of Victory rather than the unit name and number. Perhaps this standard was only carried at religious ceremonies, like the one depicted in the fresco.

CHAPTER 6
THE FALL OF ROME AND THE DARK AGES

'The world is grown so bad, that wrens make prey where eagles dare not perch.'
WILLIAM SHAKESPEARE, *RICHARD III.*

CARAUSIUS, NORTH SEA USURPER

CARAUSIUS WAS A MILITARY LEADER who established a North Sea Empire in 296 after an uprising against Maximian, emperor in the west. Little is known of his early career except two passages from the later Latin chroniclers Aurelius Victor and Eutropius, both of whom suggest he played a key role in Maximian's earlier campaigns in Gaul against *bagaudae* rebels and invading Alamanni. Writing seventy-five years after the event, Aurelius Victor (in *De Caesaribus*) says that 'Carausius, a Menapian, distinguished himself in this war, an uprising of the *bagaudae*,' while shortly after Eutropius (*Breviarium*) added that 'Carausius, a man of very humble birth, had gained a great reputation in a command on active service with the army.' We have numismatic evidence here to back up their claims of service under Maximian given that Carausius later minted coins specifically commemorating seven continental legions. This is unusual since the North Sea Empire he established is usually described as comprising Britain and, for a time, north-western Gaul only.

The two key 'facts' one can determine from the short quotes by Aurelius Victor and Eutropius above are that Carausius was of the Belgic Menapii tribe by birth, and was of humble origin. Both details are worth pursuing. First, the Menapii are mentioned in the historical record for the first time by Julius Caesar in his *Conquest of Gaul* where he describes his campaigns against the various Belgic tribes in 57 BC, the second year of his activity in the region. Here they supported the neighbouring Nervii, providing 9,000 warriors, though they only became the focus of his direct attention the following year when he targeted the tribes on the Atlantic coast where the Menapii resided. These tribes had seized Roman officers collecting provisions for Caesar's eight legions further south, sparking a full rebellion. The threat to the Romans here was on a smaller scale than in 58 BC when Caesar had fought the Helvetii and German Suebi, or indeed in his initial campaign against the Belgic tribes in 57 BC. Because of this, Caesar for once split his army, sending some legions north and some south. He himself took the largest force to attack the Veneti, a large tribe on the coast of Armorica. After a lengthy campaign he was again victorious. However, his second legionary spearhead was less successful, with the two tribes targeted refusing to submit to Rome. These were the Menapii and their Morani neighbours. Both were eventually pacified during Caesar's preparations for his 55 BC first invasion of Britain, and though they then rebelled along with many of their tribal neighbours in the Great Gallic Revolt of 52 BC, they were finally pacified and incorporated into the embryonic Roman province of Gaul.

With tribal territories stretching from Boulogne-sur-Mer in northern France to the Rhine Delta, the Menapii were noted for their maritime prowess, and by the time of Carausius had long been resident in the province of Gallia Belgica. Their *civitas* capital there was Cassel (Roman Castellum Menapiorum) near the coast in modern Flanders, the site originally a Menapii *oppidum* defended settlement. Under Roman rule it quickly became the centre of an extensive road network which linked the coast to the northern *limes* in Germania Inferior and Germania Superior to the north and east. The Romans colloquially knew the region as Gallia Comata, meaning 'long-haired Gaul'; it was highly prized for its heavy open soils which permitted large-scale agricultural exploitation.

The Menapii, as with the Batavians to their north, were noted warriors and much sought after as auxiliaries in both the Principate and Dominate phases of empire.

The Fall of Rome and the Dark Ages

GENIO
PRAETORI
SACRVMPI
TVANIVSSE
CVNDVSPRAE
FECTVSCOHIIII
GALLOR

Indeed, a cohort of Menapian auxiliaries is detailed in inscriptions as serving in the north of Britain in the second century, while the *Notitia Dignitatum* details a legion called the Menapii Seniores in the early fifth century. The Menapii were also noted seafarers, with Carausius a highly experienced sailor himself. Topically, the region had also recently been the subject of a major climate change event, this causing a rise in sea levels that inundated large areas along the coast which displaced thousands of the local inhabitants there.

Turning to Carausius' 'very humble birth', the reference in Eutropius is later echoed by Orosius (*The Seven Books of History Against the Pagans*) who called him 'a man of lowly birth to be sure'. We learn no more than that, though it should be noted that this self-made-man narrative is very common among contemporary historians narrating the lives of emperors, for example with Diocletian. Indeed, such is the frequency with which a lowly background is implied for men of power at this time that it could almost be interpreted as a narrative trope.

Carausius' actual name is uncertain. Neither Aurelius Victor, Eutropius nor Orosius give his full name, while the various panegyrics to Constantius Chlorus covering the later reconquest of the North Sea Empire do not mention him by any name at all, simply describing him as a 'pirate' and similar.

In the case of Carausius, some of his coins do give an abbreviated formal name, this styled IMP C M AVR M CARAVSIVUS, which translates as 'The emperor Marcus Aurelius M. Carausius'. Meanwhile, on the Gallows Hill milestone found near Carlisle (the only non-numismatic mention of Carausius in Britain), a fuller name is given by expanding the M CARAVSIVUS above to MAVS CARAVSIVS, with MAVS a shortened version of either MAVSEVS or MAVSAEVS. This is clearly a Latinisation of a Menapii name. Thus, our closest guess to Carausius' full title once he usurped (incorporating all of the contemporary conventions) would be IMPERATOR CAESAR MARCVS AURELIVS MAVSAEVS CARAVSIUVS PIUS FELIX AVGVSTVS. For the reader's ease, I choose to style him Marcus Aurelius Mausaeus Carausius in this work. A final note on names here, the use of Marcus Aurelius as an addition to the formal *tria nomina* was very common across Roman society in the third century following Caracalla's *constitutio Antoniniana*, with the emperors Probus, Carus, Carinus, Numerian and even the great Diocletian all following the convention. This is a good example of Carausius associating himself with imperial power following his usurpation, a common feature of his rule

Our final item of insight into Carausius' character in an admittedly poor data set comes from Orosius again (*The Seven Books of History Against the Pagans*) who says he was 'quick in thought and action'. Thus, piecing together all of the above insights and interpretations, Carausius comes across to us today as an experienced imperial trouble-shooter who played a leading role in Maximian's campaigns against the *bagaudae* and Alamanni, and later was one of Roman Britain's better known usurpers.

In Graham's image, Carausius is portrayed at the height of his power when many today might style him as the British emperor. His fine helmet is a Heddernheim-style cavalry sports helmet with an impressive plume of large feathers, while he holds in his left hand a *causia* Greek-style flat cap. On top of his leather *thoracomacus* he wears a *lorica squamata* scale-mail coat, while his greaves are based on a third-century specimen found near Nijmegen (Roman Noviomagus) on the Rhine. His imperial garments include a *paludamentum* large purple-fringed cloak and a pure white *candida* tunic. Reproduced with kind permission from Osprey Publishing.

The Fall of Rome and the Dark Ages

Egyptian Legionary, Early Dominate

Reconstruction of a Roman soldier from a painting on linen found at Deir el Medineh near Luxor in Egypt. This unique portrait was probably used as a mummy shroud and shows the man in a white *tunica* and a reddish brown cloak. The tunic is decorated with *clavi* that feature arrow-shaped terminals, and bands on the wrists similar to those seen in frescoes from Dura Europos.

Enhancing a photo of the original, Graham discovered what appeared to be a ring buckle on the belt which also had two silvered fittings. This was a very common type of arrangement in the third century. The original painting, and the subsequent reconstruction, were the subject of a feature Graham published in 2012 in the volume *Wearing the Cloak: Dressing the Soldier in Roman Times*, edited by Marie-Louise Nosch.

The Fall of Rome and the Dark Ages

Early Dominate Street Scene, Vindolanda

STREET SCENE IN THE *VICUS* civilian settlement at Vindolanda, the famous vexillation fort near Hadrian's Wall west of Dere Street. Built along the line of the pre-Wall Stanegate Road which marked the post-Agricolan northern frontier in the original province of Britannia, Vindolanda remained in use through to the end of the Roman occupation of Britain. Its form changed many times over the years, with, for example, the Antonine fort there being demolished by Septimius Severus prior to his first invasion of the far north in 209. This was replaced by a new fortlet built to the immediate west at a location previously used for extramural occupation. The Antonine fort platform was then reused to build some 250 circular huts laid out back to back in rows of ten, with roads and drains between. The purpose of this dramatic change is unknown to us today, but one might reasonably speculate that the huts were used to house native workers employed in the Severan repair of Hadrian's Wall, or perhaps to provide shelter for any local natives displaced when Severus and his enormous army headed north in Scotland, eviscerating all before them.

Graham's scene here is set outside the west gate of the later third-century fort that replaced the Severan structures. Painted as part of a series for the site's interpretation panels and reproduced here with the kind permission of the Vindolanda Trust.

LATE THIRD-CENTURY OFFICERS

BY THIS TIME, AS THE empire transitioned out of the 'Crisis of the Third Century' into the Dominate phase of empire, long-sleeved tunics and trousers of Germanic origin were becoming a standard feature of Roman military clothing across the empire. These are shown here.

The two lower figures are based on wall paintings from the Pharonic temple at Luxor in Egypt which had been converted into a Roman fort by this period. The cloak and tunic of the bottom left soldier show circular decorations called *orbiculi*, based on numerous finds from Egypt. Such decorations had a variety of origins, for example eastern styles or classical geometric designs with figurative motifs of classical deities. Their inclusion here on tunics of German design shows a typically Roman merging of frontier and traditional styles into something new.

The Fall of Rome and the Dark Ages

ROMAN WARRIORS

Early Fourth Century Legionaries

TWO DOMINATE PERIOD LEGIONARIES. The warrior at left wears his full armoured panoply, including a ridge helmet. This was one of two new designs which became ubiquitous across the Roman military as the Dominate era progressed, replacing earlier designs including the legionary Imperial Gallic type. The other new design was the Spangenhelm. Both were usually made of iron, though sometimes bronze, and mass-produced in imperial *fabricae*. Ridge helmets were made by creating a bowl of two or four parts, these designs called 'Intercisa' and 'Berkasovo' types, which were then held together by a central longitudinal ridge. The former had ear holes (as depicted here) while the latter didn't. Copied from a Sassanid Persian design, the earliest known example dates to around 280 and was found in the Saxon Shore fort at Richborough. Given the simplicity of their construction it proved easy for Roman armourers to add levels of protection to ridge helmets as required, including nose guards, a brow ridge, cheek guards and deep neck guards.

Meanwhile the Spangenhelm design originated in the Central Asian steppe, its vector of transfer into the Roman military being the various Sarmatian tribes fighting with and against the Romans from the time of Trajan's campaigns in Dacia in the early second century. The basic design features a framework of metal strips that connect between three and six longitudinal plates, giving a more conical appearance than the more rounded ridge helmet. Again, given the simplicity of the design, it proved easy to add nose guards (these sometimes integrally built into Spangenhelms), a brow ridge, cheek guards and deep neck guards. Two features unique to this design were the frequent addition of eye protectors resembling modern eyeglass frames, and chainmail aventails to provide neck protection.

For offensive weaponry, by this period the legionaries and *auxilia* were all now armed with *hasta* long spears and *spatha* long swords, with many also equipped with javelins and darts. The javelins came in a variety of types, for example the armour-piercing *spiculum*, this a technological innovation combining the features of the earlier Roman *pilum* with German throwing spears and featuring a characteristically large barbed head. Another armour-piercing javelin type was the *angon*, a weapon of Frankish origin featuring a barbed head on a long narrow socket or shank made of iron, this mounted on a wooden haft. It is the latter which Graham has depicted with his legionary here, held in his left hand along with the *hasta*. Meanwhile *plumbatae* or *martiobarbuli* lead-weighted darts were a specific innovation of the Dominate phase of Empire. These were carried in clips on the back of the legionary and auxiliary large oval body shields, such as that pictured here, and could be thrown over-arm for distance or under-arm to give a steep descending trajectory designed to fall on the heads of an approaching enemy. This particular shield design is based on an example found in Egypt.

The other figure in Graham's fine painting is shown in the classic 'undress' uniform of this later period, with again the long-sleeved Germanic tunic, and with his cloak decorated with purple coloured motifs. He wears the round 'pillbox' tetrarchic cap, named after the famous monument in Venice which shows the original four tetrarchs. To contemporary audiences, the hat was most likely known as the *pilleus pannonicus*.

Roman Warriors

The Fall of Rome and the Dark Ages

Front Line on the Irish Sea

Graham's loving reconstruction of the late Roman fortlet at Caer Gybi at Holyhead on Anglesey, North West Wales. Graham firmly believes that this unique site deserves more recognition, since it is one of the best-preserved fortifications in Roman Britain, its walls still standing almost to their full height. The site also features a later early medieval church built within its walls and dedicated to St Gybi (and from which it takes its modern name). The Roman fortlet featured a naval base which served to protect the vulnerable coastline of north-western Wales from raiders from across the Irish Sea, this an increasing problem as the Dominate progressed. To assist this task, a signal station was built on nearby Holyhead mountain. With thanks to Menter Môn for allowing reproduction here.

Naval Scout on the Rhine Frontier, Later Fourth Century

By this period the *Classis Germanica* regional fleet on the Rhine had long disappeared, to be replaced by *ad hoc* fleets as and when required. The campaigns of Julian the Apostate against the Alamanni in the later 350s provide an excellent example of this. Julian, the nephew of Constantine I, had been appointed the *caesar* in the west by Constantius II in 355 with the specific task of restoring order to Gaul which was suffering from the Alamanni and Frankish warbands raiding deep into imperial territory. Here, he struggled to feed his army, given the extensive dislocation to the regional economy. He therefore turned to Britain for grain, effectively a redoubt to the west free of predating Germans, building a new fleet in 356 to transport the produce from there. The Greek sophist and rhetorician Libanius provides a detailed commentary on why this was necessary, saying (*Oratio*):

> In the past, grain was shipped from Britain and up the Rhine. But after the barbarians took control they did not let it pass. Most of the ships, dragged onto dry land long before, had rotted. A few did still sail, but these unloaded their cargo in coastal ports, so it was necessary for the grain to be transferred on wagons instead of the river, which was very expensive. [Julian] thought that there would be problems if he was not able to restore the traditional means of grain shipment, so he quickly built more ships than before, and put his mind to how the river could take receipt of wheat.

The fleet Julian built here was enormous – he spent ten months constructing 400 new vessels to add to the 200 still seaworthy he had inherited in Gaul, giving him a total of 600 ships. Zosimus (*New History*) says the total was actually 800, and adds that they were built along the Rhine with timber felled in local forests.

Here, Graham has illustrated a naval scout serving on the Rhine during Julian's Alamannic War. He wears Germanic dress, with a state-manufactured ridge helmet. Graham's reconstruction of this is based on a particular example found in Worms, Germany. Meanwhile, also of note is the high quality Kerbscnitt style military belt. Originally published in Osprey Publishing's *Imperial Roman Naval Forces 31 BC – AD 500* Reproduced with the kind permission of Osprey Publishing.

The Fall of Rome and the Dark Ages

Roman Warriors

Auxilia Palatina of the Later Empire

Major changes occurred at the beginning of the fourth century in the Roman military establishment. The major threats by this time were mass migration into Roman territory by Germanic and Gothic confederations, the growing power of Sassanid Persia in the east, and later the predations of the Huns deep into imperial territory in both the west and east. Such trauma necessitated the radical changes instituted in the Roman military by Diocletian and later Constantine I. By the end of the latter's reign in 337 these changes were manifest in six broad ways, these being:

- A general levelling of the difference between the legionaries and auxiliaries in terms of their equipment, roles on campaign and in battle, and their standing within the Roman military establishment.

- Military units in general being smaller (sometimes much smaller), with an emphasis on creating brigades of differing troop types (and ultimately field armies) appropriate to a given task rather than having a single type of homogenous force.

- From the time of Constantine I, a clear distinction between *comitatenses* field army troops and *limitanei* border troops. This followed the adoption of a defence-in-depth strategy as the imperial experience transitioned from offence to defence, with the latter acting in a policing and 'trip wire' role on the borders of the empire, and the former deployed far back to counter any significant incursion into imperial territory.

- A much larger mounted component within the field armies, with a greater range of specialist types.

- The gradual disappearance of the Principate regional fleets, with a reversion to the Republican concept of *ad hoc* fleets created as required.

- Again reflecting earlier Republican practice, the increasingly widespread use of *foederate* irregular troops, initially armed in their own fashion but under Roman officers, and later under their own officers.

As part of this levelling off of the difference between legionaries and auxiliaries, a new type of the latter now also appeared. These were called *auxilia palatina*, and they were first raised by Constantine I to help bolster the legions in his field armies. Some of the most senior units were given names, for example the Petulantes, Heruli, Cornuti and Brachiati who fought with Julian at Strasbourg. Many units of *auxilia palatina* were recruited directly from the individual Germanic tribes, each having a strong sense of élan that matched or even bettered those of the legions.

Here Graham has drawn three *auxilia palatina* warriors from the early fourth century, based on catacomb frescoes from Italy and research by Raffaele D'Amato. The first (top) is a soldier from the via Latina catacomb in Rome. In this image he represents the Pharonic army of Rameses II chasing the Israelites across the Red Sea. It was quite common to show ancient warriors, as here, depicted in a contemporary panoply, and surprisingly the Roman army are often represented in art as the villains, perhaps a reflection of how the civil population viewed the military. The painting may show a *centenarius* of an *auxilia palatina* unit serving in Rome. He wears typical late Roman *comitatenses* infantry equipment, including a highly decorated ridge helmet and *lorica hamata* hauberk, and carries a large round plank body shield. In his right hand he wields a *spatha*, while in his left he carries a *hasta* and *lancea*.

Graham's second figure is a portrait of a very young soldier serving with an unknown *numerus* (a generic term for a late Roman unit of organisation) of *auxilia palatina*. He died and was buried in Syracuse in Sicily in the via Maria catacomb. The fresco there clearly shows a ridge helmet of the 'Intercisa' type, and his red tunic is decorated with purple *clavi*. The shield design has been revised since it was first published in Graham's *Roman Military Dress* in 2009, and is the subject of ongoing research into the shield patterns shown in the *Notitia Dignitatum* by Dr Marko Jeluši.

Graham's final *auxilia palatina* is based on another character found in the via Latina catacomb, the warrior shown as one of the soldiers at the crucifixion of Christ casting lots for his clothes. As already discussed, the 'swastika' symbol on his cloak has no connection to its twentieth-century meaning.

Lepontius in Strasbourg

A RECONSTRUCTION OF THE late Roman soldier Lepontius, based on his funerary stele found in Strasbourg (Roman Argentoratum). This is now displayed in the archaeological museum there. Uniquely, Graham has chosen not to show Lepontius as a standard bearer as others have, believing that a bird behind him in the stele, either a cockerel or poorly realised eagle, was originally resting on a now lost architectural feature not a standard. Graham therefore thinks that the monument may not have been a tombstone at all, but perhaps part of a much larger relief. This does make some sense, as otherwise Lepontius would be encumbered with both a large *hasta* and an *aquila* standard: this would not only have been impractical but unique as a depiction.

The Fall of Rome and the Dark Ages

Roman Warriors

The Fall of Rome and the Dark Ages

Hunnic *Bucellarii*

FINELY DRESSED HUNNIC WARRIOR, perhaps a *bucellarii* bodyguard of Flavius Aetius, the last great *magister militum* of the Western Empire. *Bucellarii* (meaning 'biscuit eaters') was a term used to describe the mercenaries who often formed the personal bodyguards of late Roman military leaders and members of the aristocracy. They proved highly successful, and by the early sixth century had become a formal component of early Byzantine armies where they were styled *boukellarioi*. Though such warriors were usually of Germanic origin, Flavius Aetius was well known for recruiting his bodyguards from among the Huns given his long standing association with them.

Here the bodyguard wears a white linen *paragauda podheres* tunic over a red linen knee-length under-tunic called a *kamision*. Over both is worn a *paenula* type cloak. All the garments are richly decorated with purple wool. This is one of Graham's most popular illustrations and appeared in his Osprey volume *Roman Military Clothing 3*, co-produced with Raffaele D'Amato. It is reproduced here by kind permission of Osprey Publishing.

THE FALL OF ROME AND THE DARK AGES

CHRISTIANITY IN THE FAR NORTH

TOWARDS THE END OF THE fourth century a small Christian church was built at the old Stanegate fort site at Vindolanda, within the courtyard of the commander's original *praetorium* house. This church continued in use until at least the beginning of the fifth century, at a time when the original commander's house was in ruins. This image was painted for the Vindolanda Trust in 2002, though never published, and is shown here for the first time. Courtesy of the Vindolanda Trust.

The Fall of Rome and the Dark Ages

New Colonists

After the disappearance of the *Classis Britannica* regional fleet in the mid-third century the eastern seaboard and river systems of Britain became increasingly vulnerable to Germanic raiding across the North Sea. For example, it is notable that Carausius was originally appointed in the later third century by Maximian to clear the North Sea of endemic piracy, as detailed above. This was only a temporary measure, and even the huge expense of building the later Saxon Shore forts in the south-east failed to stem the tide. By the later fourth century the severity of this relentless raiding had disrupted the regional economy to such an extent that the elites and middle classes there who could afford to leave began to do so. As the fifth century began the east coast had become severely depopulated, with those leaving resettling in the west of the diocese or, increasingly, in the Armorican Peninsula in Gaul. This itself was depopulated after civil unrest in the fourth century. The new émigrés arriving there from Britannia gave the region the name by which it is known today, Brittany.

Meanwhile, back on the east coast in Britain those raiding were increasingly employed as Germanic *foederates* by the Romano-British elites, especially after the last Roman field army troops left for the continent in the early 400s. Soon they were settling, with their families following.

Here we see two of these early Germanic settlers as depicted by Graham, both members of the warrior elites within their communities and possibly former *foederates*. The influence of late Roman clothing in their dress is very evident, with the figure at left based on finds from Morning Thorpe in Norfolk. His white tunic, belt with metal fittings and spear are perhaps echoes of late Roman official regalia.

Meanwhile, the figure on the right is based on finds from Taplow in Buckinghamshire. He wears a warrior-style jacket of dark blue wool, featuring red wool tablet woven bands brocaded in gold thread and yellow wool. These fine images are published by courtesy of Penelope Walton Rogers of the Anglo-Saxon Laboratory in York.

Byzantine Warriors

THE WESTERN ROMAN EMPIRE ENDED in 476 with the forced abdication of the last western emperor, Romulus Augustulus, with the protagonist of his demise a Roman general of Germanic decent called Odoacer. However, the empire in the east continued to thrive as the Byzantine Empire, lasting in some form until 1453 when Constantinople was finally conquered by the Ottoman Turks.

Here we see two senior officers of the early-to-mid phase of the Byzantine Empire. The figure at left, originally painted by Graham for *By the Emperor's Hand* by Timothy Dawson, represents a courtier of the period 650–900. He is wearing Persian-inspired garments. These include a long sleeved *skaramangion* tunic and *mantion* cape. Meanwhile, another Persian-style riding coat is also held by the Roman officer on the right; his clothing is based on finds from Egypt dating to the seventh century. He also wears leggings decorated with Persian motifs and a hooded *dalmatica* of wool worn over a linen under-tunic.

The Fall of Rome and the Dark Ages

Domestic Life in Late Antiquity

These illustrations were painted by Graham for the University of Kent Visualisation of the Late Antique City conference in 2014, working with Dr Luke Lavan.

In the first image, the colours of the couch are based on a late Roman painting, while the sandals under the couch, the footstool, the three-legged table with glass jug and the puppy all appear on Roman funerary reliefs. In the second image (opposite) a mother teaches her daughter how to spin wool. In the final image, both the clothing (including the sprang cap) and the doll are based on surviving examples found in late Roman Egypt.

The Fall of Rome and the Dark Ages

Roman Warriors

182

The Fall of Rome and the Dark Ages

Byzantine Warriors on the Syrian Frontier

These three figures were painted by Graham for Osprey's *Roman Military Clothing 3* by Raffaele D'Amato. They are reproduced courtesy of Osprey Publishing. The illustrations show soldiers from the Roman army based in Syria and Palestine in the sixth and seventh centuries in the lead-up to the disastrous battle of Yarmouk in 636. Mounted at the rear is a *biarchus* of the *tertio dalmatae vexillatio comitatensi*, this an elite unit listed in the *Notitia Dignitatum*. Meanwhile, on the left is a soldier of the *lykokranitai* based on a mosaic from Mount Nebo in Jordan. Finally, on the right is a soldier of the *vandali Justiniani*, as depicted on a mosaic from Umm Al-Rasas, also in Jordan.

The Emperor Heraclius

Another image painted for *Roman Military Clothing 3*, once more published by courtesy of Osprey Publishing. Here we see the great Byzantine Emperor Heraclius resplendent in his imperial finery. He wears a padded riveted garment called a *zoupa* which corresponds to the earlier *subarmalis*. This new clothing item was also worn under armour.

The Fall of Rome and the Dark Ages

Roman Warriors

The Fall of Rome and the Dark Ages

Byzantine Courtiers

This image was painted for *By the Emperor's Hand: Military Dress and Court Regalia in the Later Romano-Byzantine Empire* by Timothy Dawson and published by Frontline Books. The painting shows three junior Byzantine courtiers from the ninth to the eleventh centuries. The continuation in use of traditional late Roman clothing is very clear here. In the centre a *strator* carries an ornamental whip to represent his office in the imperial stables. Meanwhile, at left, a *mandator* carrying a red staff is shown, his role to relay orders or imperial decrees. Finally, on the right Graham has drawn a *disupatos* who carries an inscribed scroll.

The Later Byzantine Imperial Court

More lovely imagery drawn by Graham for *By the Emperor's Hand*. This shows a later Byzantine emperor at centre from the tenth or eleventh centuries, wearing a crown mounted with semi-precious stones that resembles earlier Roman helmet crests. He also wears a pearl-decorated surcoat called an *epilorikion*. On the right a *kaisar* wears gilded armour and carries a gilded spear. He wears one black and one red boot to symbolise his halfway position between the populace and the throne. Meanwhile, on the left a *protospatharios* carries a parade helmet for the *kaisar*.

The Fall of Rome and the Dark Ages

The Fall of Rome and the Dark Ages

Female Defender of Thessaloniki

ANOTHER IMAGE PAINTED FOR *By the Emperor's Hand*. This figure represents one of the women who took part in the defence of Thessaloniki in the twelfth century. In this engagement, the women made turbans and padded garments like those worn by regular soldiers, but for use by themselves.

Medieval Byzantine Warriors

A FINAL SELECTION OF late Roman images. The left-hand figure is a last image painted for *By the Emperor's Hand* and represents a soldier wearing Persian-style *char-aina* mirror armour. Meanwhile on the right we see one of the last elite soldiers from the late Byzantine world, this a *stradiot* painted for an article in *Military illustrated* magazine which was written by the eminent author David Nicolle. This soldier reflects the desperate straits the late empire found itself in, with armour and equipment sourced from wherever possible. The helmet could be either Italian or Spanish while the massive neck gorget could be Spanish bought via Sicily. The sword may be German, while the belt and shield show Balkan influences. The quilted coat is from Ottoman Turkey.

THE FALL OF ROME AND THE DARK AGES

The Final Fall

The end of the Roman world is symbolised by these three Turkish warriors at the final siege of Constantinople, which fell on 29 May 1453. An illustration painted for *Medieval Warfare* magazine.

EPILOGUE

"Well a wise man said, 'you have to spin a good yarn before you can weave a great dream'."
ADAM SHADOWCHILD, 'PAUL' 2011.

Graham's prolific artwork continues apace. Here is a selection of his recent and ongoing projects.

ROMAN FORT PROJECT

A CONCEPT PAINTING FOR THE Roman Fort Project, part of The Park in the Past at Fagl Lane, Caergwrle, Flintshire, North Wales, 2011. Graham's brief was to produce an image of a small Roman fort which contained all the main elements. Therefore it has a headquarters, commander's house, granary and barracks. After some research Graham based the layout design on the small fort at Crawford, South Lanarkshire, in central Scotland. The finished painting did the trick and appeared in all the local press. Graham was thrilled that his design will be echoed in the final appearance of the fort which is becoming a reality.

Epilogue

CONCEPT DRAWING FOR THE ROMAN FORT PROJECT

This painting shows how the central range of administrative buildings in the Roman fort might look. The fort at Crawford was again the inspiration for the size and layout of these buildings.

From the Film *Julius Caesar*

Reconstruction of a Roman cavalryman from the MGM film *Julius Caesar*, 1953.

The costumes in the film were clearly inspired by the auxiliary cavalry depicted on Trajan's Column in Rome. One interesting detail is that the cavalry extras apparently wore leather jerkins over mail shirts. However, in reality each 'mail shirt' was in fact a few rows of metal rings attached to the lower inside of the jerkin. Similar costumes appeared in other MGM epics at the time including *Quo Vadis* (1951), *Sign of the Pagan* (1953) and most famously *Ben-Hur* (1959), starring Charlton Heston. Heston was a particular favourite actor of Graham, who went to see him on stage at the Palace Theatre in Manchester starring in *The Caine Mutiny Court Martial* in 1985. Graham's approach to reconstructing film costumes is the same as he uses for any of his archaeology-related work, basing his illustrations on as much evidence as he can find. He hopes to publish the results of this collection soon.

Epilogue

Roman Warriors

Epilogue

Soldiers from *The Robe*

Reconstruction of Roman soldiers in the movie *The Robe* (1953). This illustration for *Ancient Warfare* magazine shows a Praetorian Guard on the left and a legionary in Judaea on the right. Graham's research suggests that the legionary figure was based on either an illustration in Amédée Forestier's book *The Roman Soldier* which appeared in 1928, or even earlier drawings by the late nineteenth-century French artist James Tissot.

ON THE LEFT, A RECONSTRUCTION of a Roman legionary from the 1964 epic movie *The Fall of the Roman Empire*. The costumes in the movie are more robust-looking than in many other epics. The film ironically appeared in the very year that the Corbridge armour finds were discovered near Hadrian's Wall. That discovery would revolutionise the understanding of academics on how Roman armour worked. However, it would be over twenty years before the findings were fully published, although reconstructions in the 1970s made by H. Russell Robinson inspired the re-enactors of the Ermine Street Guard.

On the right, a reconstruction of a Roman legionary from the film *Gladiator* made in 2000. The film owed much to *The Fall of the Roman Empire* and essentially began with the same characters and same time frame. While the shields, swords and *pila* were excellent for a movie, Graham thinks the body armour and helmets were awful.

Epilogue

203

Haltwhistle Signs

Graham continues to work as a freelance illustrator. He is particularly proud of this commission from the Centre of Britain for the town sign of Haltwhistle near Hadrian's Wall. The artwork features a Roman soldier and a Border Reiver. The sign even appeared on the BBC television show *Antiques Road Trip*.

Graham has also been a regular contributor to *Ancient Warfare* magazine, with both articles and illustrations. A Greek hoplite prepares for combat, while his servant or slave looks after the horses they have used to reach the battle site.

Roman Warriors

Epilogue

Civil War Scene, Dukinfield Hall

In spite of his Merseyside roots, Graham has had a long association with the Manchester area and with the Greater Manchester Archaeological Unit, which would have celebrated its fortieth anniversary in 2020. One of Graham's paintings produced for the unit, which sadly no longer exists, was this commission for a booklet on Dukinfield Hall. Ironically, the inspiration for the magnificent fireplace in the painting was that at Speke Hall near Liverpool.

STANDING GUARD AT THE REMOTE site of Castleshaw in Greater Manchester are two interpretation panels featuring Graham's reconstruction work. Both were commissioned by the Greater Manchester Archaeological Unit in 2010. Graham worked full time with the Unit in 1981–2.

Epilogue

Graham's work is always of great interest to Roman re-enactors. Here members of the French Group Pax Augusta purchase books and prints when Graham's work was on display at the museum in Grand in the Vosges region of France in 2009.

Marius' Mules Exhibition

A major part of Graham's work in recent years has been his contribution to the Mules of Marius display, an interactive exhibition featuring full-scale reconstructions of military equipment, fantastic model dioramas and figures, and Graham's illustrations of Roman soldiers enlarged to life size. The display has been to many museums in Europe including, as advertised here, at the evocative site at Kalkriese, scene of the actual Varian disaster. We end, as do all great archaeological discoveries, in a car park!

BIBLIOGRAPHY

Books and chapters written and illustrated by Graham Sumner
Roman Army: Wars of the Empire. London: Brassey's, 1997.
Roman Military Clothing 1. Oxford: Osprey Publishing, 2002.
Roman Military Clothing 2. Oxford: Osprey Publishing, 2003.
Roman Military Dress. Stroud: The History Press, 2009.
'Painting a reconstruction of the Deir El Medineh portrait on a painted shroud and other soldiers from Roman Egypt', in *Wearing the Cloak: Dressing the Soldier in Roman Times*, ed M. Louise Nosch. Oxford: Oxbow Books, 2012.
'Clothes', in *The Encyclopedia of the Roman Army*, ed. Y. Le Bohec, Hoboken: Wiley Blackwell, 2015.
'Roman Soldiers: Fashion icons or military elite', in *Egypt as a Textile Hub: Textile interrelationships in the 1st millennium AD*, ed. A. de Moor C. Fluck & P. Linscheid. Tielt Belgium: Lannoo, 2019.

Books illustrated by Graham Sumner
Birley, R., *Garrison Life on the Roman Frontier.* Carvoran: Roman Army Museum Publications, 1994.
——, *Civilians on Rome's Northern Frontier.* Carvoran: Roman Army Museum Publications, 2000.
——, *Vindolanda 2004.* Carvoran: Roman Army Museum Publications, 2004.
Cowan, R. H., *For the Glory of Rome: A History of Warriors and Warfare.* London: Frontline, 2007.
——, *Roman Conquests: Italy.* Barnsley: Pen & Sword, 2009.
D'Amato, R., *Roman Military Clothing 3.* Oxford: Osprey Publishing, 2005.
——, *Imperial Roman Naval Forces 31 BC–AD 500.* Oxford: Osprey Publishing, 2009.
——, *Arms and Armour of the Imperial Roman Soldier: From Marius to Commodus, 112 BC–AD 192.* Barnsley: Frontline, 2009.
Dawson, T., *By The Emperor's Hand: Military Dress and Court Regalia in the later Roman-Byzantine Empire.* Barnsley: Frontline, 2015.
de la Bedoyere, G., *Roman Villas and the Countryside.* London: English Heritage, 1993.
Elliott, S., *Romans at War.* Oxford: Casemate Publishing, 2020.
——, *Roman Conquests: Britain.* Barnsley: Pen & Sword, 2021.
Evans, R., *Roman Conquests: Asia Minor, Syria and Armenia.* Barnsley: Pen & Sword, 2011.
Fields, N., *Roman Conquests: North Africa.* Barnsley: Pen & Sword, 2010.
Fischer, T., *Das Romerkastell Eining und Seine Umgebung.* Regensburg: Verlag Friedrich Pustet, 2016.
——, *Regensburg Zur Romerzeit.* Regensburg: Verlag Friedrich Pustet, 2018.
Forty, S., *Hadrian's Wall: Operations Manual.* Yeovil, 2018.
——, *Roman Soldier: Operations Manual.* Yeovil, 2019.
Fry, Plantagenet Somerset, *Roman Britain.* Newton Abbot: David & Charles, 1984.
Goldsworthy, A., *Hadrian's Wall: Rome and the Limits of Empire.* London: Head of Zeus, 2018.
Grainger, J. D., *Roman Conquests: Egypt & Judaea.* Barnsley: Pen & Sword, 2013.
Koepfer, C., Boes, N. & Kurtz, T., *Roms Legionen.* Kalkriese: Museum und Park Kalkriese, 2019.

Lendering, J. & Bosman, A., *Edge of Empire: Rome's Frontier on the Lower Rhine*. Rotterdam: Karwansaray, 2012.

Mason, D. J. P., *Roman County Durham: The Eastern Hinterland of Hadrian's Wall*. Durham: Durham County Council, 2021.

Neal, D. S., *Lullingstone Roman Villa*. London: English Heritage, 1991.

Sage, M. M., *Roman Conquests: Gaul*. Barnsley: Pen & Sword, 2011.

Strickland, T. J., *Roman Chester*. Hendon Mill: Hendon Publishing, 1984.

——, *The Romans at Wilderspool*. Warrington: Greenalls Group, 1995.

——, *Roman Middlewich*. Middlewich: Roman Middlewich Project, 2001.

Magazine articles written and illustrated by Graham Sumner

'Roman Camel Corps: Dromedarii Units 2nd century AD', *Military Illustrated* 90, Nov. 1995.

'The Soldiers who Killed Christ: Pontius Pilate's Bodyguard', *Military Illustrated* 120, May 1998.

'The Roman Army on Screen, part 1. *Caesar and Cleopatra* (1945)', *Ancient Warfare* IX.2, 2015.

'The Roman Army on Screen, part 2. *Quo Vadis* (1951)', *Ancient Warfare* IX.4, 2015.

'The Roman Army on Screen, part 3. *Julius Caesar* (1953) and *Sign of the Pagan* (1954)', *Ancient Warfare* IX.6, Feb–Mar 2016.

'The Roman Army on Screen, part 4. *The Robe* (1953) and *Demetrius and the Gladiators* (1954)', *Ancient Warfare* X.2, Jul–Aug 2016.

'The Roman Army on Screen, part 5. *Ben-Hur* (1959)', *Ancient Warfare* X.4, Nov–Dec 2016.

'The Roman Army on Screen, part 6. *Spartacus* (1960)', *Ancient Warfare* X.6, Mar–Apr 2017.

'The Roman Army on Screen, part 7. *King of Kings*', *Ancient History* 10, Jun–Jul 2017.

'The Roman Army on Screen, part 8. *Barabbas* (1961) and *Pontius Pilate* (1962)', *Ancient History* 12, Oct–Nov 2017.

'The Roman Army on Screen, part 9. *Cleopatra* (1963)', *Ancient History* 14, Feb–Mar 2018.

'The Roman Army on Screen, part 10. *The Fall of the Roman Empire* (1964)', *Ancient History* 16, Jun–Jul 2018.

'The Roman Army on Screen, part 11. *Masada: The Antagonists* (1981)', *Ancient History* 18, Nov–Dec 2018.

'The Roman Army on Screen, part 12. *Gladiator*', *Ancient History* 22, Jul–Aug 2019.

'The Roman Army on Screen, part 13. *King Arthur* (2004)', *Ancient History* 24, Nov–Dec 2019.

'The Roman Army on Screen, part 14. *Centurion* (2010)', *Ancient History* 25, Jan–Feb 2020.

'The Roman Army on Screen, part 15. *The Eagle* (2011)', *Ancient History* 26, Mar–Apr 2020.

'The Roman Army on Screen, part 16. Ben-Hur (2016)', *Ancient History* 27, May–Jun 2020.

'A Roman Optio from Chester: Waiting in the Wings', *Ancient Warfare* XI.4, Nov–Dec 2017.

'Marcus Aurelius Nepos and his Wife: Married for Eternity', *Ancient Warfare* XII.1, Jun–Jul 2018.

'The Imperial Imaginifer: Face to Face', *Ancient Warfare* XII.6, Jun–Jul 2019.

'El atavío militar romano en el siglo I d.C', *Desperta Ferro* Numero Especial X, Dec–Jan 2017.

'Del cingulum al balteus El atuendo militar en el siglo III', *Desperta Ferro*, Numero Especial XVII, Dec–Jan 2019.

Ancient Sources

Ammianus Marcellinus, *The Later Roman Empire*, ed. Hamilton, W. London: Penguin, 1986.

Apuleius, *The Golden Ass*, ed. Walsh, P. G. Oxford: Oxford World Classics, 2008.

Marcus Aurelius, *Meditations*, ed. Staniforth, M. London: Penguin, 1964.

Julius Caesar, *The Conquest of Gaul*, ed. Handford, S. A. London: Penguin, 1951.

Marcus Cato, *De Agri Cultura*, ed. Ash, H.B. and Hooper, W. D., Harvard: Loeb Classical Library, 1934.

Cassius Dio, *Roman History*, ed. Cary, E. Harvard: Loeb Classical Library, 1925.

Claudian, *Works*, ed. Platnauer, M. Harvard: Loeb Classical Library, 1989.

Diodorus Siculus, *Library of History*, ed. Oldfather, C. H. Harvard: Loeb Classical Library, 1939.

Eusebius, *Ecclesiastical History: Complete and Unabridged*, ed. Crusé, C. F. Seaside, Oregon: Merchant Books, 2011.

Eusebius, *de Vita Constanti*, ed. Cameron, A. and Hall, H. Oxford: Clarendon Press, 2011.

Flavius Eutropius, *Historiae Romanae Breviarium*, ed. Bird, H. W. Liverpool: Liverpool University Press, 1993.

Quintus Horatius Flaccus (Horace), *The Complete 'Odes' and 'Epodes'*, ed. West, D. Oxford: Oxford Paperbacks, 2008.

BIBLIOGRAPHY

Gaius, *Institutiones*, ed. De Zulueta, F. Oxford: Oxford University Press, 1946.
Gildas, *De Excidio et Conquestu Britanniae*, ed. Williams, H. A. Moscow: Dodo Press, 2010.
Historia Augusta, ed. Maggie, D. Harvard, Loeb Classical Library, 1921.
Sextus Julius Frontinus, *Strategemata*, ed. Bennett, C. E. Portsmouth, New Hampshire: Heinemann, 1969.
Herodian, *History of the Roman Empire*, ed. Whittaker, C. R. Harvard: Loeb Classical Library, 1989.
Homer, *The Iliad*, ed. Rieu, E. V. London: Penguin, 1950.
Justinian, *The Digest of Justinian*, ed. Watson, A. Philadelphia: University of Pennsylvania, 1997.
Libanius, *The Julianic Orations*, ed. Norman, A. F. Harvard: Loeb Classical Library, 1989.
Livy, *The History of Rome*, ed. Foster, B. O. Cambridge, MA: Harvard University Press/Loeb Classical Library, 1989.
Paulus Orosius, *Seven Books of History Against the Pagans*, ed. Woodworth, R. I. New York: Columbia University, 1936.
Pausanias, *Guide to Greece: Central Greece*, ed. Levi, P. London: Penguin, 1979.
Pliny the Elder, *Natural History*, ed. Rackham, H. Harvard: Harvard University Press, 1940.
Pliny the Younger, *Epistularum Libri Decem*, ed. Mynors, R. A. B. Oxford: Clarendon Press, 1963.
Plutarch. *Lives of the Noble Greeks and Romans*, ed. Clough, A. H. Oxford: Benediction Classics, 2013.
Polybius, *The Rise of the Roman Empire*, ed. Scott-Kilvert, I. London: Penguin, 1979.
Quintilian, *Institutes of Oratory*, ed. Selby Watson, J. Scotts Valley, California: Create Space, 2015.
Statius, *Silvae*, ed. Nagle, B. R. Bloomington: Indiana University Press, 2004
Suetonius, *The Twelve Caesars*, ed. Graves, R. London: Penguin, 1957.
Cornelius Tacitus, *The Agricola*, ed. Mattingly, H. London: Penguin, 2003.
——, *The Annals*, ed. Grant, M. London: Penguin, 2003.
——, *The Histories*, ed. Fyfe, W. H. Oxford: Oxford Paperbacks, 2008.
Strabo, *The Geography*, ed. Roler, D. W. Cambridge: Cambridge University Press, 2014.
Albius Tibullus, *Catullus. Tibullus. Pervigilium Veneris*, ed. Cornish, F. W., Postgate, J. P. and Mackail, J. W. Harvard: Loeb Classical Library, 1989.
Aurelius Victor, *De Caesaribus*, ed. Bird, H. W. Liverpool: Liverpool University Press, 1994.
Zosimus, *New History*, ed. Ridley, R. T. Leiden: Brill, 1982.

ACKNOWLEDGEMENTS

THIS BOOK WOULD NEVER HAVE seen the light of day without the unwavering assistence of my dear partner Elaine Norbury. Elaine is not only there every day but tirelessly helps out with IT, costumes, models of forts and countless awkward questions. Thanks are also due to other members of the family for their help and support, especially cousins Kevin and Christian Hand who have posed as Romans for illustrations and my step-sister Claire who made a splendid Anglo-Saxon Queen.

I owe a great deal to my lecturer at Wrexham Art School, Keith Bowen, one of Wales's leading artists. We have remained in contact ever since. While studying at art school I also met my great friend Andrew Connolly who has shared with Elaine and I several adventures exploring Roman sites across Europe.

The Grosvenor Museum in Chester always holds a special place for me. I was first employed as a volunteer with the museum's excavation section in 1981. It was with Tim Strickland, MBE, head of the section, that I created my first archaeological reconstruction paintings, one of which appears in this book. Tim and I have remained close friends and I recently painted a Second World War scene for a biography of his father. Many years later the curator of the museum, Dan Robinson, allowed me to hold my first exhibition of paintings there in 2008. Now Elizabeth Montgomery the current curator has helped with illustrations for this book.

My first employment after leaving college was with the Greater Manchester Archaeological Unit. I obviously made an impression on the then Director Philip Houldsworth who twenty years later commissioned me to work at Moresby in Cumbria. I would later work freelance with John Walker, Norman Redhead, and Mike Nevell many times. Later I was employed by Manchester City Planning Department and many friends and colleagues there including Chris McGough, Harmesh Jassell and David Lawless also helped with various illustrations.

For almost twenty years I was a member of the Ermine Street Guard, the pioneering group in Roman re-enactment. I owe a great personal debt to the chairman Chris Haines, MBE, and to Martin White, Stuart Wilson, Clive Constable, Peter Johnson I, Peter Johnson II, John Hindle, Tony Segalini, Richard Eastwood, John Brinded, Derek Forrest and Chris Jowett who have all posed for many paintings or simply enjoyed the cameraderie of the shared highs and lows of re-enactment. CJ and PJ II in particular are stars.

Over the years I have met many re-enactors from other groups who have always helped with photos or discussions over projects. They have included Paul Karremans, Marc Sanders, Dirk Jansen and Marion Boeckhout, who supplied me with an image of my Dromedarius from their collection, Dan Shadrake, Paul Elliott, Ivan Perello, Cesar Pocinya, Aitor Iriarte, Florian Himmler, David Reinke whose advice is always welcome, Martin Moser and Ivor Lawton, who are always incredibly knowledgable and helpful with pictures of their amazing Roman shoe reconstructions, Steve Rogers, Amy Wallace, Paul Harston & Cellan Harston from 'The Park in the Past', Christian Koepfer who has provided much needed assistance with the Mules of Marius illustrations, Terry Nix who provides invaluable help with my Hollywood Romans artwork, Robert Vermaat, Steve Kenwright, Marcus Junkelmann, Dario Battaglia, Marco Zanchini and finally Lesley Anne-Holmes & Luciano Verzola of Medieval Design who supplied me with reconstructed garments.

It has been a privilege to meet or correspond with many of the leading Roman specialists, archaeologists and historians over four decades, They have included Barri Jones, Mike Bishop, Jon Coulston, Simon James, Birgitta Hoffman, David Woolliscroft, Lawrence Keppie, Peter Connolly, Carol Van Driel-Murray, David Mason, David Neal, Fernando Quesada-Sanz, Paul Holder, Fiona Handley, Lloyd Lewellyn-Jones Judith Sebesta, Bryan Sitch, Bill Giffiths, Richard A.

ACKNOWLEDGEMENTS

Gregory, Michael Speidel, Thomas Fischer, Barbara Borg, Kurt Hunter-Mann, Guy Stiebel, Eckhard Deschler-erb, Andrew Birley, Luke Lavan from the Visualisation of the Late Antique City project, Plantagenet Somerset Fry, Anique Hamelink, Ursula Rothe and, whenever I have strayed into Anglo-Saxon territory, Penelope Walton-Rogers has always been on hand to help out. None of the pictures in this book would have been possible without their dedicated work.

My first big commission, literally also in terms of size, was from Patricia Birley for the Roman Army Museum on Hadrian's Wall. The commission was for four large murals which would remain in place for almost thirty years. During this time I also worked on numerous occassions with Robin Birley.

Other commissions have been for English Heritage; Hadrian's Wall Trust, with thanks to Nigel Mills for his continuing support over the years; the Lake District National Park, with special thanks to Holly Beavitt-Pike and Lisa Keys for their assistance on the Ravenglass interpretation panels; Cumbria County Council; Northumberland National Park; and the Roman Middlewich Project.

Since my first exhibition at the Grosvenor my work has been on display at many museums both in Britain and abroad. This would not have occured without the assistance of many individuals but in particular Craig Barclay, an ex-Ermine Street Guard comrade from Durham Oriental Museum, Stephen Bull, Thierry Dechezlepretre, Jérôme Fage, Manfred Hahn, Rene Hanggi, Peter Van der Plaetsen, Magi Seritjol, Marco van Bel and Patrick Tostevin. Since 2016 my work has also featured as part of the Mules of Marius exhibition run by the amazing Thomas Kurtz.

Several authors in their own right have also been generous with help or advice. They include Raffaele D'Amato who allowed me to use some of his own research in this book, Andrea Salimbeti, Ross Cowan, Arjen Bosman, Jona Lendering, Nic Fields, Ian Stephenson, Duncan B. Campbell, Boris Burandt, Timothy Dawson, Lindsay Powell, a former Ermine Street Guard comrade, Mel Martin, Martin M. Winkler, Françoise Gilbert and Charles W. Evans-Gunther who can fit every scrap of historical fact about King Arthur onto the back of a postage stamp!

I am also grateful to Jasper Oorthuys and Sandra Alvarez from Karwansaray publishing, Tim Newark editor of *Military Illustrated* magazine, Edouardo Kavanagh from *Desperta Ferro* magazine, Laura Callaghan and Jo Davies from Osprey Publishing, Belinda Gallagher from Miles Kelly publishing for allowing me to use a photo of a book cover, Peter Kemmis-Betty from the History Press and Phil Sidnell of Pen and Sword Books.

In recent years Elaine and I have enjoyed attending the Textiles from the Nile Valley bi-annual conference in Antwerp. Cacilia Fluck, Petra Linschied, Dominique Cardon, Annette Paetz gen Schieck, Hero Granger-Taylor, John Peter Wild, Felicity Wild, Frances Pritchard and Lise Bender-Jorgensen have all both inspired and helped me with my research into Roman military clothing. John Peter Wild in particular is a legend and I am also grateful for his patience in reading through my text for *Roman Military Dress* and for generously giving his time to write a foreword for that book.

It has also been a great pleasure over the years to meet David Breeze, Brian Dobson, Jorit Wintjes, Richard Bridgeland, Ed Valerio, Valerie Maxfield, Mark Corby, Kurt Kleeman and other attendees and organisers of the Roman Army School held at Durham. The lectures there are a constant source of inspiration as indeed are some of the lecturers. Richard is also yet another Ermine Street Guard veteran and Carausius devotee, while Jorit's knowledge of all things naval is second to none. Elaine and I also have fond memories of meeting Kurt for a tour of Remagen, which has more than a bridge!

Sadly, inevitably some of those mentioned above are no longer with us and working on this book has been consequently somewhat of an emotional journey which was far harder than I had ever imagined. It evoked many memories, thankfully mainly good ones.

Finally, this book would not have been possible at all without the persistence of my friend and publisher Michael Leventhal. He suggested many times over the last few years that we produce this book together. However, I had no interest in writing a 'how to paint' type book – there are many better artists out there who have already done that and I would point the reader to James Gurney on that score. Equally I had little enthusiasm for writing a historical account of the Roman army when again there are so many more qualified to do that. Thankfully, I was introduced recently to Simon Elliott and it has been scary how many things we have in common, not just a love of ancient Romans. It has been a pleasure to work with him and he has done more than just write captions, which is what I had originally envisaged, but he has taken this book up to another level.

Adrian Goldsworthy who I met and became friends with at the Roman Army School has very kindly taken the time to write a foreword for this book.